# Lost on the Yellow Brick Road

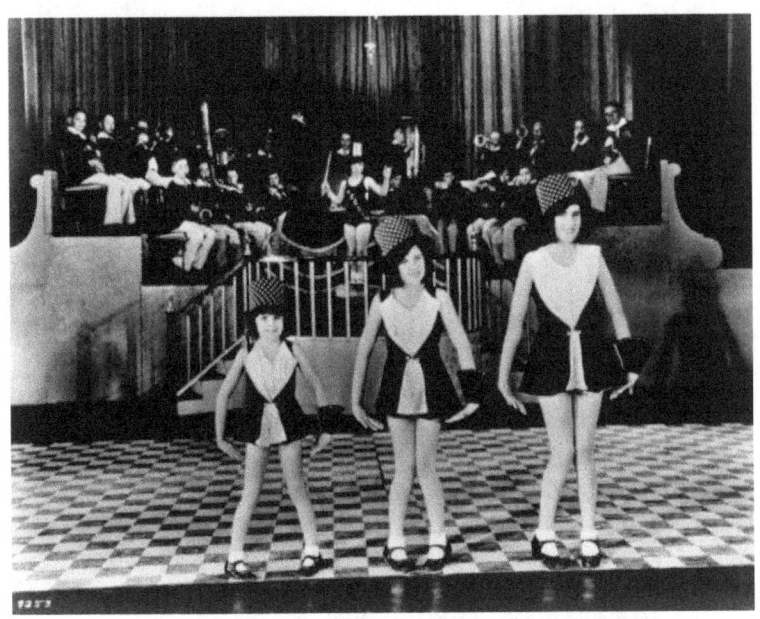

*The Gumm sisters – Judy, Virginia and Mary Jane.*

### By
### Michael Lee Simpson

### With Michael Selsman

Lost on the Yellow Brick Road Copyright © 2018 by Troika Publishing Group.  All rights reserved. Printed in the United States of America and in the United Kingdom.

Except as permitted by the United States Copyright Act of 1976, no part of this publication may be reproduced, stored in a retrieval system or transmitted, in any form or by any means, electronic, mechanical, photocopying, recording, or otherwise without the prior written permission of the publisher.

ISBN-13: 978-1-68454-095-2
ISBN-10: 1-68454-095-X

Visit us at www.m3publishers.com

# FOREWORD
# By Michael Selsman

I represented Judy Garland in the years 1962-64 as her publicity agent, and I still say Judy was the movie star I most enjoyed working with. She was kind to a young man when she could have been cruel; she was serious about her career, and she was a loving mom to her three children. Judy had talent to spare as a singer, dancer, comedy and dramatic actress and I still love her to this day. I undertook this book (and screenplay), with Michael Lee Simpson, to show how Judy triumphed against her parents, the men in her life, the show business establishment, and particularly MGM. The name Judy Garland, in her movies and recordings, will be a bright, shining star long after the others have been forgot.

"I used to live in a room full of mirrors, all I could see was me. Now it's becoming clear. I take my spirit and I crash my mirrors, now the whole world is here for me to see."

—Judy Garland

Chelsea, London—June 22, 1969. The hum of droning wind and honking horns wafted in the thick morning air. Traffic bustled down a maze of slick winding streets in the fog and drizzling rain. Black crows soared under purple clouds blooming on the horizon, cawing, flitting and fluttering over rooftops, casting shadows on an affluent district of cottages curling through the Royal Borough. Inside one of the bungalows, far beyond the hill, beams of sunlight sliced through a window where a sweeping view of Greater London laid beyond parted suede curtains. Silhouettes peeled away to unveil the blinking of stoplights, cars crossing Putney Bridge, umbrellas walloping open, ferries sailing Chelsea Harbour, trains roaring underground in Sloane Square Station, smoke lingering from chimneys. Knightsbridge and the River Thames bound the scope of it all. Beautiful, picturesque, the city sparkled, unmasked by the flush of dawn. And maybe, far, far in the distance, a rainbow.

There was a gust of wind as a crow swooped down, landing in a straw nest on the windowsill, eyes darting about, peeking inside, narrowing in on a cold and quiet bathroom with a tub half-full of water. Below a tall oval mirror, the vanity was a disastrous sight; a hairbrush in the sink, make-up, eyeliner knocked over, perfume, gold jewelry,

cigarette butts, wet towels and clothes strewn about. On the floor, a shattered wine glass and two-dozen pills, red capsules scattered across the white marble tile. A prescription bottle rolled by, stopping before thin strands of graying red hair: "JUDY GARLAND—SECONAL SODIUM: 97 mg." And behind it, reflected in the shards of glass, a motionless figure slumped over by the commode. There was a knock at the door, and a man's voice, raspy and deep from the lungs, bellowed from the other side. "It's locked, are you in there?"

A stretch of silence overtook the freezing, damp bathroom.

"Hello? Open up!"

Another knock, hollow and echoing.

"Are you in there?! Come out!"

A third time, knocking harder. Strong wind gusted outside.

"Open the fucking door!"

The wind howled with his desperate screams, banging, pounding, rattling the doorframe.

"JUDY, OPEN UP RIGHT NOW!"

And, there it was—small bare feet, blue ankles and pudgy toes resting like phantoms against the tile. One more bang and the heels of sparkling ruby slippers appeared as if from another world, tapping together on yellow bricks...click...click...click. Alas, a glimmer from the gems, flooding the view with magical glittering light, and the road unfurled into paper—bold letters in scratchy black-and-white print.

## *The New York Times*—London, June 23: JUDY GARLAND, 47, FOUND DEAD

Her successes on stage and screen were later overshadowed by the pathos of her personal life, was found dead in her home today. The cause of death of the 47-year-old singer was not immediately established, and an autopsy was scheduled. [Reuters reported that police sources said a preliminary investigation revealed nothing to suggest that Miss Garland had taken her own life.]

Miss Garland's personal life often seemed a fruitless search for the happiness promised in "Over the Rainbow," the song she made famous in the movie "The Wizard of Oz."

Her father died when she was 12 years old; the pressures of adolescent stardom sent her to a psychiatrist at the age of 18; she was married five times; she was frequently ill; her singing voice faltered, and she suffered from the effects of drugs she once said were prescribed either to invigorate or tranquilize her.

She came here at the end of last year to play a cabaret in another of the "comeback" performances that dotted her last 15 years. Three months ago she married Mickey Deans, a discotheque manager. It was Mr. Deans, her fifth husband, who found Miss Garland dead on the bathroom floor in their home in the Belgravia district.

Also surviving are three children, Liza Minnelli, the singer and actress, and Lorna and Joseph Luft.

Funeral arrangements were incomplete tonight.

## PROLOGUE

Eighty miles northwest of Superior, just west of the Mississippi River, the tale of the Yellow Brick Road began in the heart of a paper mill town of no more than two thousand people. A splintery arched sign with peeling red paint stood before the picturesque village: "Grand Rapids, Minnesota," served as a ramshackle gate to iron country in all its glory. Lollipops glistened in the window of a candy store atop baskets of taffy and honey jars. Past the bank, a blacksmith shop where a man with a wooden leg and mustache chewed tobacco, basking in a shower of sparks as he hammered his forge. Across the rickety wooden street was the general store, and further down, a barber shop on the corner of Tenth and Main where a Mr. Rogers of some sort had been cutting hair for thirty-seven years, and where God's children sang gospel on Sunday.

On the far side of Grand Rapids was the Gumm residence. They lived in a white-shingled, two-story house nestled among purple honeysuckle flowers and pine trees, standing on the corner of Second and Fourth Street. Francis "Frank" Gumm looked proudly in the bedroom mirror, resembling magician dressed in a blue double-breasted pinstripe suit and purple-checkered bow tie. He put on a fedora and adjusted his collar, sporting a marvelously mischievous smile. The scent of chicken noodles drifted into the room from the kitchen, coming from soup simmering on the stove, boiling over the distant laughing of children. The infamous

Ethel Gumm, stout and plump, just under five feet, looked out the window and scowled. She wrinkled her brow with crossed black eyes as she squinted straight ahead, her shadow thrown on sheets that whipped on a clothesline in the front yard.

"Girls! Supper!" She yelled.

Their two little daughters, Virginia and Mary Jane, ages three and five, chased each other on the grass, dancing between hanging shirts and blouses that billowed in the breeze. They ran past the window where Ethel had stuck her head out, eyes widening before hurrying inside the house.

Chasing the pizzazz of vaudeville through celebrated circuits, and with southern roots that ran generations deep, Frank was a gifted soprano soloist. His true home was not the south, but a simple wooden platform known as the vaudeville stage. Before long, his talents were celebrated; they touched hearts with a sweet tenor voice that never failed him, and windpipes that inspired the nonbelievers.

*The Cloquet Pine Knot*—which swirled, blurring into a screaming headline: "RISING STAR FRANK GUMM!" "Mr. Gumm impresses one as a very capable young man in his line of endeavor and most desirous of pleasing the theatre-going public of Cloquet..."

*The Murfreesboro Gazette*—which spun, flying into view. A young Frank, all smiles, performing onstage at a carnival. Headline, large print in a boxed editorial: "VAUDEVILLE ON THE UP-AND-UP!" "A star is born..."

*The Chattanooga Star*—which twirled in circles, landing with a solid thud. Headline: "FABULOUS, REMARKABLE PERFORMANCE!" "...continues to please audiences with that rich southern brogue..."

Memory Lane rolled by with the landscape on train rides barreling across the countryside, snippets of long lost dreams surfacing like ghosts from the past. Frank saw his mother in the window, his father, his siblings, generations of shoemakers; his entire childhood in Murfreesboro, Tennessee came and went. A shimmer of light burst in the reflection of the glass until little Frank, no older than thirteen, fell from the clouds, posing comically with a glued-on mustache and tipped bowler hat, ukulele over his shoulder. As the memory faded, Frank was left alone in his seat, gazing at the scorching sun as it rose above the earth, bathing the rocky summits with a tinge of red jewels.

Unbeknownst to him, Mr. Gumm was destined to meet a feisty little girl in the Midwest where the largest shows in town exclusively played at the Orpheum Theatre in Superior, Wisconsin—one of the many "picture houses" in the Head of the Lakes area. The theatre's grandiosity was viable down to the last brick; its architecture sparkled with the glamour of a palace, furnished with diamond chandeliers and terrazzo floors. Most prominently, a winding grand staircase stretched into the foyer where a statue of the Greek prophet Orpheus conquered the entrance. Frank crooned beneath the

spotlight while Ethel, only a teenager at the time, played piano for large audiences; all a vast sea of heads and faces in the dark. The soon-to-be Mrs. Gumm pounded out vigorous accompaniments in the pit as Mr. Gumm, with that fabulous tenor voice, led the audiences in song. Like hand in glove, they began using stage names, Jack and Virginia Lee. Velvet curtains parted onstage, and on those wonderful nights, only her silhouette was revealed, washed away by shadows. Frank appeared from the wings with quick strides to center stage. "Good evening, ladies and gentlemen! My name is Jack Lee! This here is Virginia Lee!" Applause as Ethel stood and bowed modestly before resuming her seat at the piano, Frank turning sideways to wink at her. "She will open our program by playing 'Alexander's Ragtime Band.' Please, if you would, observe the dainty size of her hands. Let them not fool you, for they are attached to the quickest fingers you'll ever see!"

The audience erupted with laughter, clapping as she held up her hands. Flexing her palms, she straightened her spine and closed her eyes as the auditorium fell silent. In one swift movement, she struck the opening chords and her fingers flew across the keys.

Ethel came from Michigamme, Michigan; a place where lighthouses towered high and rhinestone flowed from the sand dunes. The sweltering sun dropped behind the earth, burning into the paper of a photograph—a family portrait from 1903—ten-year-old Ethel with her siblings and Canadian parents, Eva Fitzpatrick

and John A. Milne. The firstborn of eight children, she was raised by a railroad engineer and sickly housewife, poorer than dirt.

Come summertime, when the mosquitos' sucked blood and the money ran hot, the Milne clan would work the carnival circuit. Fireworks exploded by nightfall, blossoming like flower pedals over a circus of balloons, sparks trickling down from a cherry-black skyline, the reflection of ambers bouncing off the rubber and casting a kaleidoscope of flashy bright colors upon puppet shows, stuffed animals, trotting ponies and spinning fortune wheels. A medicine wagon rolled among the parade, a traveling show making its grand entrance with horses clattering on cobblestone before parking on the fairgrounds. Dressed in clown costumes, the Milnes beamed, greeting the crowd with enthusiastic waves while presenting an exhibit of potions with recipes, miracle elixirs and fuming vials on a table. People waited in line by the dozen to gulp them down, cringing at the sour taste of juice derived from the cascara tree. Legend has it, Mr. Milne—assuming the role of a grand hypnotist—stood on a platform and swung a ticking pocket watch back and forth. Men, women and children dropped to the ground as all eight Milnes scrambled to collect wallets and purses, stuffing their pockets with cash and coins.

In January of 1914, it was official for the star-crossed lovers. The vaudeville gypsies, the talented Jack and Virginia Lee, became Mr. and Mrs. Gumm at last. Frank, the romantic that he

was, slipped a diamond ring on Ethel's finger in the parlor of the Milnes' house on Bank Avenue—she in a gown of ivory silk and he, as expected, dressed to the nines in his usual pinstripe suit. After a passionate kiss, the newlyweds immediately moved to Grand Rapids and bought a classic burlesque theatre downtown. After years of climbing the cabaret ladder, they owned their own establishment on Main Street. It was deemed the New Grand—an old, one-story clapboard building displaying a handmade marquee: "THE NEW GRAND—It Pleases Us To Please You." They smiled out front with a local photographer. As the bulb flashed—the moment was captured, frozen in time—and off to the races they went.

*The Herald Review*—swirling, twirling, spinning like a flying saucer, landing on the front page. Headline: "THE GUMMS BUY THE NEW GRAND"

By the Roaring Twenties, entertainment ran wild in their blood at their latest venue. Cash grew on every tree in town around that small vaudeville cinema. It was a magical time in a magical place where popcorn overflowed from striped paper bags, crunching under the feet of chitchatting patrons mingling on a floor of cotton candy and squashed bubble gum. Every Friday was entertainment night, and the motion picture era was just beginning to boom. At the box office, a gloved hand would reach out and collected the tickets, which in turn passed out handbills, the cover printed with dual images of a movie poster along with Virginia and Mary Jane in a

vaudeville act: "THE NEW GRAND PRESENTS TONIGHT...'THE CABINET OF DR. CALIGARI' & THE GREAT GUMM FAMILY." Guests waited in line at the concession stand, cornering the popcorn machine while others dropped pennies into a jar, purchasing caramel apples and cotton candy. In the auditorium, a 16mm projector, wheels clicking and reels turning, sprang columns of light across the smoke-filled room where Robert Wayne's silent film, *The Cabinet of Dr. Caligari*, flickered upon the curtains. Ethel struck her famous chords from the pit, pounding the keys as the ending credits rolled. The curtains parted and the spotlight tilted down, shining down on Virginia and Mary Jane tap dancing in bunny costumes.

After a short time, Ethel found herself in the Itasca Hospital Examination Room. Her sharp, black eyes squinted at Dr. Binet, a bone-thin physician nearing retirement, staring right back at her through his round, silver-rimmed bifocals.

"What you're talking about is an abortion, Mrs. Gumm," he said.

"I already have two children," snapped Ethel. "I need to get rid of it. We're not having another child."

"Abortions are illegal, not to mention extremely dangerous. You could get a fatal infection, and if you don't die, aftereffects that could last a lifetime."

"This child will not be born. I'll drink castor oil, liquor, poison if I have to."

"I'm sorry, Mrs. Gumm, but you have no choice. Perhaps it's a blessing in disguise."

Ethel stood and walked out into the hallway, brushing past Frank and storming out of the hospital. Dr. Binet stepped outside the door and spoke softly, "Mr. Gumm, make her have the baby. After it's born, you wouldn't take a million dollars for it."

Frank rubbed his forehead and nodded, the very thought making him ill as a thunderous crescendo swelled in his ears.

Not heeding to the news, Ethel resumed playing piano while Frank sang opera in the months that followed. Mrs. Gumm suffered, so the New Grand suffered—and most of all, the music suffered. One night, Ethel's hands slid off the keys and she slumped over, gagging and pouring with sweat. The orchestra stopped and Frank ran over to grab her shoulders. The shocked audience gasped as she ran offstage and down the steps, bursting through the door of the restroom and vomiting violently in the toilet.

Her pregnancy wasn't easy—not by a long shot. Believed to be a boy, the unborn child was named Frank Jr. Gumm. Brilliant columns of light shone upon a female fetus in the womb, her eyes closed, floating slowly. A sad, lost lullaby echoed, perhaps the voice of an angel. From the time she kicked in the womb, all she ever wanted was to be loved. On June 10, 1922 at 5:30 A.M., a window on the second floor of Itasca Hospital, very small, and in the distance glowed brighter and brighter amidst the bellowing whine of a

rainstorm. That's where the first yellow brick was placed. Seven pounds. Frances Ethel Gumm was born. Frank, Virginia, Mary Jane and some Nurses hovered around Frances "Baby" or "Babe" Gumm, wrapped in a blanket, wailing in Dr. Binet's arms. He handed Frances over to Ethel, who perhaps unsurprisingly, remained cold and emotionless.

# CHAPTER ONE

Religion, at least in the beginning, was of paramount importance to the Gumm family. They dressed in their Sunday best one afternoon, standing at the altar in St. Mary's Church. Father Basler held newborn baby Frances in his arms, dipping her in a tub of water, baptizing her in the name of the Father, the Son and the Holy Spirit. "For you are God's masterpiece created in Christ to do good works which God has prepared for you to do. You are sealed by God in baptism and marked as Christ's own forever," whispered the priest, grinning when Baby Gumm clacked her lips. The congregation clapped as an Angelus bell chimed from the tower, the clang of metal carrying across town.

It was especially hot that spring. The sun blazed with the color of red apples and the clouds floated above like marshmallows shriveling over heat. Bees buzzed around purple honeysuckles planted in front of the Gumm house. From inside, there was rich music crackling from a Victrola. "Ave Maria" played in a pink room of porcelain dolls and jungle animals. By the window, there was a bassinet in which Frank crouched over, looking down at his Frances Baby Gumm. She stared back, smiling from ear-to-ear. As he hummed the melody, she giggled and hummed along, too.

Carolers paraded the streets on Christmas Eve in 1924, marching past the New Grand on Main Street. Pulled by eight horses, a carriage

rode by with jingling bells and a jolly Santa Claus. Curtains parted to a winter wonderland inside the theatre, a theme of paper igloos, wreaths, wrapped gifts, lights, star-spangled Christmas trees, ornaments and showers of white feathers. Frank addressed the full house while Ethel raised her hands from the pit. Virginia and Mary Jane were dressed in elf costumes, hands on their hips, candy cane batons over their shoulders. "Good evening! We hope you enjoyed the film at the one and only New Grand Theatre!" shouted Frank. "Next up, a group near and dear to my heart. A trio very special to our family, so very talented. My wife and I have raised them to have open hearts and pour out their souls in song and dance since the day they were born. Welcome the Gumm Sisters!"

There was a round of applause, and behind the curtains, a Rudolf nose glowed red in the dark. Babe was almost three by then, dressed head-to-toe in a reindeer costume, standing on a hatbox in front of Ethel, who placed on the antlers, buttoned up the sides and tied on more bells.

"I don't want to go," whined Baby Gumm.

Frank came backstage, a look of slight confusion on his face. "Are you coming?"

"You go out and sing or I'll wrap you around the bedpost and break you off short. If you don't get out on that stage, I'll choke feed you with a bar of soap instead of dinner tonight." She held out her boney finger, pointing it at Babe before turning to Frank. "She doesn't want to go out."

"Why not?" asked Frank?

Ethel didn't even respond. She just left, a breath of frustration leaving her as she stomped back into the shadows.

Frank knelt down, looking at Babe in the eyes and pinching her nose. "Just pretend you're on the North Pole. Santa will bring something good this year. Deal?"

Babe smiled as Frank handed her a candy cane baton and kissed her on the cheek. As Ethel starts a bouncy holiday tune, Babe scurries onstage to join her sisters, cute as a button, beaming. The girls crooned "Jingle Bells" from start to finish while they all shake dinner bells.
"*Jingle bells, jingle bells, jingle all the way...*"
People sang along, whistling, cheering. Applause was the loveliest sound in the world to Baby Gumm, a soothing lullaby crafted by angels when hundreds of clapping hands rung wildly in her little ears. Acclaim meant adoration, and adoration meant love. She would later claim her childhood was lost, steered off onto a darker tangled road, the root as to why she withered into something of a candle burning at both ends, cast in the role of a tortured artist. But those eyes. Those big, brown, unforgettable eyes reflected a standing ovation like two mirrors as she breathed it all in, a symphony of delightful beauty. She grinned, bowed, blew kisses, saw her father whistling and stomping his feet. White feathers drifted to the floor, c the applause slipping into

dim vibrations through a tunnel of droning white noise.

Arising from the sound, a distinct voice resonated in a much bigger arena, calling from the future; perhaps as much as thirty years after "Jingle Bells." A spotlight boomed on, blasting through the feathers when the silhouette of a tiny woman in a short skirt and high heels appeared onstage with a microphone. "I was never wanted. I was never loved. Not as a child. Never. That's all I ever needed—and I never got it from anybody..."

But it wasn't that way. Not entirely, at least.

Clinging and clanging bells intensified to a higher level, drowning out the voice as the silhouette faded into the loom of darkness. Feathers turned into crisp snowflakes falling like diamonds from a black starry sky—back to the wonders of childhood. Bundled up, Frank, Virginia, Mary Jane and Babe were in the midst of a snowball fight, taking cover behind bunkers and forts. They plopped down on their backs, waving their arms, four swans on a blanket of white, forming snow angels with broad wings.

The snow melted and the flowers bloomed by mid-March. Grimy, muddy hands would grab mason jars lined up and down the sidewalk. A frog croaked in one, a cricket chirped in another, fireflies glowed in several more. Springtime at its finest. Baby Gumm's friend, her only friend, was a Scotch tomboy named Ina Mary Ming, a slender athletic girl always in overalls, known by her peers as the good and great Muggsy from St. Cloud. They danced on the grass together, snickering and tossing the jars around.

"What do you want to be when you grow up?" asked Muggsy.

"A ballerina," said Baby Gumm.

They hooted and hollered and ran across the street.

Muggsy was an escape—a getaway from the devastating family dynamics that ruined the spirits of all three children. The Gumms' all but declared war at their home. One could always hear shouting, pots and pans thrown across the room. There was, indeed, too much yelling and screaming. Plates and glass clanked and shattered. Oftentimes, Baby Gumm would run out and sit under a tree on the front lawn, sobbing.

Summertime was filled with picnics and ziplines. Adolescence came with highs and lows. Periods requiring a long string of auditions proved to be one of the lows. Ethel's broken loyalty to Frank was the main reason Baby Gumm hated going, so, amazingly, Muggsy was allowed come along. Ethel would be behind the wheel, speeding like a bat out of hell on Mint Canyon Highway, far up the mountain while Muggsy and Baby Gumm sat in the backseat, drawing in coloring books.

Once at an audition, the three of them waited patiently in some rickety wooden chairs while some sweaty, overweight Theatre Owner in a cheap suit came out of his office.

"What do you mean she's too young?" asked Ethel angrily.

"That's what I mean, Mrs. Gumm. "She's too small."

"She's the best singer you'll ever see."

"That may be, but she looks like a dwarf."

Ethel pondered for a moment. "What do I do?"

No more than three minutes later, the Theatre Owner led Ethel into his office. There was soon noisy moaning, lustful sex from behind the door.

The next day, like nothing ever happened, a kite glided swiftly in the wind before cutting down and smashing into the pavement of a schoolyard. Baby Gumm and Muggsy chased after it, skipping, squealing with laughter—but, in typical Gumm fashion—once rehearsals and long car rides to Walnut Grove started in the fall, the two Musketeers never saw each other again. Muggsy walked away, turned and waved goodbye to a teary-eyed Baby Gumm as she dragged the kite around the block and disappeared for good.

One thing always remained the same, and that was music. Music was always the constant, the focus for the family. There was seldom a moment when a key wasn't being played, or a chord wasn't being struck, or a voice wasn't singing in the Gumm household. Frank would beam as Ethel played the piano, sitting there, puff on his pipe, blowing smoke rings and strumming his ukulele with all three daughters on his lap.

But Frank—the unassuming man that he was—harbored a double life, a secret he kept

close to his chest. In St. Mary's confession booth one bitter cold afternoon, silhouettes lurked as Father Basler sat on the left side of the latticed screen, Frank on the right. Every word spoken echoed as the jagged shadows swayed to and fro in the booth.

"Do you know why you're here, Mr. Gumm?" asked the priest, folding his arms.

"I have somewhat of an idea," said Frank, groaning, breathing deeply, head buried in his hands.

"I've heard some disturbing rumors about you, Mr. Gumm."

"You can't believe everything you hear."

"As much as you've done for this town, as much as you're loved here, you and your family need to leave before it gets worse. Cover your own tracks."

What he was talking about was something very sinister, the dark side of Frank not many people knew. Sure, Ethel may have known, but even today most don't recognize what was going on back then—his hands slipping out of white gloves, gripping a boy's shoulders in the dressing room of the New Grand—fingers moving up and down the boy's clothing, followed by kissing, caressing, groping.

"I don't think we can move away from here, Father."

"Homosexuality isn't tolerated in Grand Rapids. I'm only protecting you, Frank. I'm sorry." Father Basler sighed and left the booth, leaving Frank alone in the shadows.

The sky was a sheet of chocolatey black that night, complete with stars that twinkled like gemstones strewn over the tapestry of an old jewelry box. A blanket of clouds split ways from the moon, producing a single beam of light on the Gumm house in vivid blue, as if a spotlight shining onstage during a sad, tear-jerking production. The living room window glowed a rich yellow with muffled screams coming from inside.

"YOU QUEER!" screamed Ethel, pacing as she threw a lamp across the room. "The WHOLE TOWN is talking about it!"

Frank turned away, unable to look her in the eye. "It's not how you think it is, Ethel," he said. He leaned against the piano and lowered his head.

"Every time you walk down the street now people will say, 'Oh, that's that Frank Gumm, the pansy.' Or 'that's Frank Gumm's family!'

Ethel clutched a violin and chucked it against the wall, breaking the wood and strings. In the other room, the three girls snapped awake and crawled out of bed. They peeked through the cracked door, watching their mother spitting on their humiliated father. Ethel, in pure agony, almost as if her guts her being dragged out of her stomach, began to cry. "As far as I'm concerned, as far as this family is concerned, this never happened," she said, wiping tears away with her sleeve.

Silent and distraught, troubled beyond words, Frank sat at the piano and started playing.

# CHAPTER TWO

The afternoon sun burned like a fireball over Antelope Valley in the Mojave Desert. Lancaster, California—all but sweeping scenery of oil wells, yucca trees and sagebrush as far as the eye can see. Dust plumes rose with fine grit in the boiling air before the wind picked up and swirled it all away, far into the plummets of the hills. Dreams of red carpet glamour and handprints on the Hollywood Walk of Fame were smashed by the cow town plagued by drought and parched sunbaked mud. Honeysuckle flowers became cactuses, hornets became scorpions scratching stucco walls. Model T convertibles rumbled through its only intersection under a hanging lamp where toothless hillbillies meandered about and sheep roam the streets. Like Grand Rapids, just another disappointment. On Third Avenue stood the Valley Theatre, a rundown building crumbling apart from the ground up, where a man on a ladder placed the last "S" of "GUMM SISTERS—FRIDAYS AT 9:00" on the marquee.

It was Frank on the ladder. He came inside the theatre lobby with a hammer in hand. Once handsome, he wasn't by any stretch of the imagination the same man who turned heads at the New Grand nine years earlier. Bald, out of breath, belly big as ever, he stopped to look around at the empty, quiet theatre. Stringed chords played delicately from behind a set of red doors. He pushed through them, walking into the auditorium where he saw Ethel in the dark, violin to her chin, also aging drastically. Her eyes were

closed, bowing as she strummed each note, passionately lost in the melody. Frank sat in one of the vinyl seats, admiring her for a moment, humming, tapping his foot. Ethel held the last note in a sustain, then lowered her violin.

"Frank, what are you doing?"

"I'm watching."

"Is the sign up?

"Just finished."

"Go get the girls for rehearsal. They're next door. Friday will be here before we know it."

Lancaster had a popular joint called the Jazz Ice Cream Shop. Colorful frozen flavors lined the counter in long rows. Lime, raspberry, chocolate, vanilla, banana split. Slurping out of root beer floats in a booth were the Gumm Sisters, almost grown. Virginia, Ms. Chatty Cathy with curly auburn hair, glossy white teeth and humongous breasts. Mary Jane, chewed gum, her lips smacking as she talked with a lisp. Both chipper and smiley. And, of course, Baby Gumm, now a thirteen-year-old pimply little thing. While her sisters had turned into fine, bright-eyed and bushy-tailed young ladies, she was well into that awkward stage of adolescence; very plain, pudgy, a pound or two short of chubby, referred to by many as the "ugly duckling" of the three.

"If Mama makes us rehearse again before Friday, I'm gonna lose it," scoffed Mary Jane, sitting back and crossing her arms.

"Me, too," said Virginia. "What's your plan now?"

"I plan on marrying Lee Kahn, have kids, maybe go sailing in the Keys," said Mary Jane,

her eyes glistening in a daydream. "Yours?"

"I'm going to marry Bobby Sherwood and get the hell out of Dodge. Have kids, who knows."

"This is the final curtain call for the Gumm Sisters," said Mary Jane as she chomped on a cherry.

"What about you, Baby?" asked Virginia.

"Me, I don't know," Baby Gumm said as she shrugged her shoulders. "Keep going, I guess."

There was a tap on the window across the shop. The girls turned to see Frank waving and making monkey gestures outside. He walked inside and slid into the booth with them, stuck a straw in Mary Jane's float and slurped. The sisters giggled with delight. They loved their daddy.

## CHAPTER THREE

Palm trees swayed against a backdrop of clouds and citrus groves in the heart of Beverly Hills, California. A glass edifice stood on the corner of Beverly Drive and Wilshire Boulevard. In one of the offices on the top floor, an engraved gold nameplate, "Louis B. Mayer, MGM Studios Executive and Co-Founder," centered on an oak desk. Movie posters were sprawled along the walls, everything from *Red Lily* to *Ben-Hur: A Tale of the Christ*, awards, plaques, a world globe and Michelangelo paintings occupied the richly furnished suite. Overlooking upscale Los Angeles, the Hollywood giant himself, a showmanship master, true Napoleon with short man syndrome, thick round bifocals and, as always, a black three-piece suit. He brewed in thought, sitting firmly in his leather chair by the window, puffing on his pipe and blowing out smoke rings as he stared straight ahead with an owlish gaze at the skyline. He poured two shots of rye whiskey, handed one to Burton Lane, a rising American composer for MGM with a lazy right eye, across from him.

"I have an assignment for you, Burton," said Mayer, straightening his glasses.

"What's that, Mr. Mayer?"

"I want you to go down to the Valley Theatre in Lancaster Friday night and see about a trio. Do you know who I'm talking about?"

"The Gumm Sisters," said Burton.

"Pay special attention to the youngest one," clarified Mayer, throwing a photograph down on his desk, one of all three Gumm Sisters. Circled,

a target drawn as a bull's-eye at the bottom of Baby Gumm. "Watch her closely."

That Friday at the Valley Theatre box office, the old gloved hand collected tickets, which in turn passed out handbills, the cover printed with dual images of a movie poster with the happy Gumm family: "THE NEW GRAND PRESENTS TONIGHT...'NOSFERATU' & THE GUMM SISTERS!" Popcorn sizzled in the machine at the concession stand. Patrons bought liquorice and Butterfingers. There was a 35mm projector in the auditorium, wheels clicking and reels turning, that sprang columns of light across the smoke-filled room, where *Bride of Frankenstein flickered* upon the curtains. Ethel again struck chords in the pit as the ending credits rolled.

Curtains parted and the spotlight slanted down on all three Gumm Sisters holding canes, donning blackface paint and overstuffed straw hats, Baby Gumm in the middle. After almost a decade of performing, they had gone from petite youngsters to fashionable, marketable talent. Frank, as always, was positioned near the wings, guitar in hand. On cue, the music began and the family performed an old classic, the girls dancing and singing, joyously yodeling the lyrics to "Zing! Went the Strings of My Heart."

"*Never could carry a tune, never knew where to start/ You came along when everything was wrong and put a song in my heart...*"

Unbeknownst to them, in the row top row near the exit, was Burton. He sat far back, silent and unnoticed, disguised by the gloom of the shadows. He crossed his legs and lit a cigarette,

watching with the intensity and curiosity of a hawk as the performance reflected in the lens of his eyepiece, glinting across the surface of the glass. The girls made bunny ears with their fingers and hopped forward.

"*Dear when you smiled at me, I heard a melody/It haunted me from the start/Something inside of me started a symphony/Zing! Went the strings of my heart...*"

Burton squinted his eye and blustered a thick smoke cloud.

"*Your eyes made skies seem blue again/What else could I do again/But keep repeating through and through/I love you, love you...*"

The girls rolled cartwheels and twirled their candy-painted canes.

"*I still recall the thrill, guess I always will/I hope 'twill never depart/Dear, with your lips to mine, a rhapsody divine/Zing! Went the strings of my heart...*"

And for the coda, Babe's voice, that wonderfully powerful voice, carried the full house, pouring out like melting gold. Burton was dumbfounded, bewildered beyond return. He said a little saying only the exit sign could hear, speaking under his breath, "Prettier than a garland of flowers..." He clapped with the audience as they were all swept off their feet.

The Gumms lived in middle-class Lancaster, a small residence on Cedar Avenue. Ethel set the table for breakfast while Virginia and Mary Jane stirred eggs and peeled potatoes. Frank sipped on his coffee, looking out the

window, seeing Baby Gumm rocking back and forth on a swing. The phone rang off the hook for many moments before Frank finally answered, "Frank Gumm speaking."

Click. Ethel grabbed the receiver and slammed it on the hook. "Nobody with any decency would call at this hour. It's rude."

The phone rang again. Ringing, ringing, ringing. Ethel rolled her eyes as Frank picked up the receiver.

"Frank Gumm speaking...alright...when?" Frank looked at his watch and then out the window again, spots Babe climbing a tree, hanging upside down and laughing. "We'll be there as soon as we can. Thank you." He hung up.

Who was that?" asked Ethel, folding her apron over the stove handle.

"It was MGM," said Frank, pondering as he sat back in his chair.

Ethel turned to him. Virginia and Mary Jane did the same. "MGM?" asked Virginia. "*The* MGM?" asked Mary Jane, eyes opening wide. Ethel came over and joined them at the table. "You're saying MGM called and wants to see us?"

"Not exactly. They want Baby," said Frank while Babe's giddy laughter came innocently from the backyard.

# CHAPTER FOUR

Corinthian columns towered over steel gates, the passage to a Greek God's fortress, and two iron lions stood on their hind legs, growling, facing each other, guarding the door to the greatest backlot in Hollywood history—a time when the old saying, "There's More Stars Than There Are in Heaven," still held true. A land of standing sets depicting various periods, all built with precision and limitless imagination. Trailers and soundstages stretched for miles below. A sleeping lion in the jungle, bliss for the cinema, the classic era. The Gumms' blue Buick chugged through the entrance. It was muggy and hot that day when thirty-year-old Roger Edens, walked through Lot 1 with Ethel, Frank and Baby Gumm. Edens was a rising figure in MGM's music department, buck-toothed, his wavy blonde hair parted to one side, blowing the breeze as he gave the Gumms a tour. As he spoke, his words coincided with the sights they saw.

"Welcome to Lot 1, Metro-Goldwyn-Mayer's land of make-believe," said Edens.

"Wow," said Frank. "This is truly amazing."

"Truly breathtaking," said Ethel.

Babe held Frank's hand, looking around in awe.

"Our standing sets can replicate anything, from medieval France to Italy and Spain—all down to an exact science. Right now, we're on Overland Avenue. *Tugboat Annie* was filmed on this street, along with *Fugitive Lovers* and *Manhattan Melodrama*. As Edens pointed to a line of office buildings, "Behind the many buildings,

offices are separated by departments, sound stages, the makeup department, the music department, warehouses, production, all the good stuff." They turned down Waterfront Street where a vastly different town appeared. "The sets are all man-made, as you can see," he explained. "They can be transformed, re-configured and re-painted to match the setting for each picture."

They walked by black pool of water, a lagoon engulfed in rubber roots and plastic trees. Edens smiled. *Tarzan, the Ape Man* was filmed here in the thickets of our own special jungle." They continued the tour through Small Town Square in a meticulously built New England Town. *The Twilight Zone* and the *Andy Hardy* movies would eventually be filmed there. The famous Waterloo Bridge stretched from the swamp and ended before Quality Street and Grand Central Station.

"Let's go have a talk in Mr. Mayer's office," said Edens. "Does that sound good, Babe?"

"Who's Mr. Mayer?"

Smoldering cigarettes polluted the office, masking a blur of faces with wafting clouds of smoke. Seated around a long glass table were the big dogs of show business. Men of broad shoulders, long jackets, wide lapels and the finest cigars. Gruff voices and stoic mannerisms. Then, one of them spoke and extended his hand.

"My name is Arthur Freed. I'm a producer and lyricist here at MGM," said Freed as extended his hand and straightened his tie. Freed was born Arthur Grossman to a poor Jewish family in the heart of Charleston, South Carolina, and lived in

a small house surrounded by oaks and Bermudian limestone, stood up. He began his career in Chicago as a song-plugger and pianist where he met Minnie Marx—mother of the Marx Brothers—on the vaudeville circuit, writing lyrics for their films before finding his home at MGM.

A man in an Armani suit stepped forward, gold watch gleaming in the sunlight streaming through the windows. "Mervyn LeRoy." A San Francisco native and pupil of Cecil B. DeMille, LeRoy was forced to become a newspaper boy following the untimely death of his father—later working in costumes and processing labs for silent films. Gigs for gagwriting came along and worked on silent films such as *The Ten Commandments*, which in turn led to savage womanizing of Hollywood starlets—Ginger Rogers, Jane Russell and Jean Harlow to name three—and now married to the daughter to Doris Warner, daughter of Harry Warner, founder of Warner Bros.

"Al Rosen, talent agent." One of those agents that floated around Hollywood, waiting to discover talent and bring them back to Mayer in an effort to make a name for himself.

"I'm Ida Koverman, the 'godmother,' so to speak as well as chief assistant to Mr. Mayer."

"Irving Thalberg, co-founder." Nicknamed "The Boy Wonder" for his youth and knack in choosing scripts, actors and actresses and the finest directors to make profitable films for MGM. Born in Brooklyn, New York, he was diagnosed from an early age with a congenital heart disease that would eventually kill him before reaching the age of forty. He worked as a store clerk out of high

school while taking a night class in typing before finding work as a secretary with Universal Studios' New York office, later becoming a studio manager in the Los Angeles region. After smashing success in producing *The Hunchback of Notre Dame,* Thalberg joined forces with Mayer to form MGM and make some of the biggest stars to date.

Burton straightened his eyepieces and looked down at Babe, flouting the rest of the room. "Burton Lane, music department."

"And I'm Louis B. Mayer," said the fat old man, adjusting his glasses and sitting up in his chair.

"Hello, everyone. I'm Ethel."

"Frank Gumm. Pleasure to meet you all."

They all shook hands.

"And you must be Frances, or I mean Baby Gumm," said Koverman, pinching the innocent child's cheeks as they smiled at each other.

Frank looked down at his daughter.

"Go outside and play for a bit, Babe. This is adult talk. Would be boring to you."

Babe ran past everyone and went out the door.

"How long did you two do vaudeville, Mr. and Mrs. Gumm?" asked Mayer.

"My wife and I used to perform it at our theatre in Grand Rapids," Frank stated proudly. "Years and years. Goes back generations."

"That's how we met," said Ethel.

"What you see in the movies, it's all right here," said Mayer. "A fairytale of clocks and mirrors where cowboys fire magnums in the eighteenth century and aliens fly through space

and into the Fourth Dimension." Mayer rose from his chair and walked slowly around the room. "It'll be a very grueling schedule, she'll attend our school, have a strict diet. Mr. Lane saw her last performance and said—"

"She's prettier than a garland of flowers," said Burton, finishing the sentence for him. "It's Judy Garland from now on."

"The magic of names is a myth," said Frank.

"I'm in the star-making business," said Mayer as he puffed on his pipe across the room, looking over with a sense of honor, respect, determination in his eyes. "I make stars. It's what I do. I can pair her with Mickey Rooney, Bojangles Robinson, Clark Gable, anybody. But what you do for me, that's a whole different story."

"I want to know the compensation," said Frank as he wrapped his arm around his wife.

"Oh, yes," said Mayer. "The money. How did I know you'd bring that up?"

Laughter filled the room. Deep belly laughter.

"Now is the time," said Mayer. "We are cutting up the pie, so to speak—who gets what, what goes where, who can or can't step on toes, etcetera."

"The lawyers, ours from MGM, Rosen repping you people. We're setting this up the right way," said Freed.

"We care most about your child's well-being. Many child stars grow up to be drug addicts, lunatics and the like. We'll make damn sure that doesn't happen," assured Rosen.

"Absolutely right," nodded Thalberg.

"We're not taking anything less than seventy-five a week," said Frank, serious about his statement.

"I'll give you a hundred," said Mayer.

"How much will be held in trust?" asked Ethel.

"Ten percent," said Mayer.

"Who will administer the trust?" asked Frank.

"We always give that responsibility to the mother," said Mayer as he sat back in his chair.

Ida cleared her throat, folding her delicate hands on her lap. "I will be her guardian until she's eighteen. I nurture our talent through childhood, make sure they eat healthy, rehearse before performances and go to school. She'll be in good hands."

"You know what Katherine Hepburn used to say? 'Your problems are taken care of. It's a wonderful sensation.'" Mayer smiled big just as Baby Gumm opened the door and ran into the office.

"And you must be Frances, or I mean Baby Gumm," said Koverman, pinching her cheeks like that of a teddy bear.

"Can we go home now, Daddy?"

"Yes, sweetie."

"Sign this first." He set a document on his desk, handing the little girl a fountain pen.

"J-U-D-Y G-A-R-L-A-N-D," said Ethel very slowly into her child's ear.

Baby Gumm looked around the room, stood up on her toes, and with her tiny hand, scribbling in childish cursive. Signed: "JUDY GARLAND"

Frank, Ethel and Baby Gumm waved goodbye and left. Mayer turned to the MGM clan.

"What can we do with a little Huckleberry Finn?" asked Thalberg.

"I'll find a way," said Mayer. "There's always a way. We just don't want another Shirley Temple."

The Gumms' Buick pulled up the driveway to their Cedar Avenue House. Frank burst through the front door, carrying Baby Gumm in his arms. Ethel came in behind them, clapping, shrieking with joy. MGM! MGM! MGM!" Baby Gumm hooted. She jumped down and ran up to Virginia and Mary Jane. "I signed with MGM!"

Virginia looked at Frank. "Is it true?"

"It sure is," said Frank, beaming.

"Seven-year contract," said Ethel as she ran her fingers through her hair. All five of them whooped and hollered and danced around in circles.

"What's going to happen?" asked Mary Jane, resting her chin on her open palm.

"Still have to make arrangements," said Frank.

Ethel took a deep breath to collect herself. "This is it, this is really it. We made it."

**"MGM legal office, Please prepare all contracts covering the services of JUDY GARLAND as an actress—Monday, September 16, 1935. Al Rosen."**

## CHAPTER FIVE

On November 16, 1935, an asphalt jungle towered towards the far heavens, cloaked in a blanket of fog. In those days, New York City was thriving with style. Men wore hats, even at work. Women did, too. Soldiers, sailors and marines thronged the streets—U.S.O. clubs held dances and gave out sandwiches and Coke. Kids were required to save silver from gum wrappers, and rubber bands and turned them into school every Friday. The students pledged allegiance to the flag without saying "under God." Patriotism was almost mandatory. Certain parts of the city still had trolleys. Crime was down—most of the young men were away at war. Most people rode the subways. Everybody smoked. There were a lot less people and cars on the street. The radio was on all the time—bulletins every half-hour kept up morale. There was no television; only music from glass 78's to play at home or on the radio. Restaurants were at a minimum, most people had dinner at home; women joined factories, manufacturing tanks and planes, and then cooked and cleaned. There were no new cars—Chrysler shut down and made tanks. GM made Jeeps, Boeing made warplanes, Henry J. Kaiser made ships. People hung flags out their windows—some showed a gold star in their windows to signify they had lost a son or husband. Everybody feared a Western Union messenger—a telegram meant someone had died.

KFI Studios was located in downtown Manhattan, home of *NBC's Shell Chateau Hour.*

The show's iconic host, Wallace Berry, set up equipment in the studio with some producers and other assistants, each dressed in slick black suits. The phone rang, rang, rang off the hook. Berry, annoyed, pointed to the telephone. "Goddamn it, answer the phone!" he shouted.

A producer grabbed the telephone. "KFI Studios." He took a step back. "Judy, it's your father."

Baby Gumm took the phone. "Hello, Daddy"

Across the country, on the third floor of Cedars of Lebanon Hospital, Frank lied in bed, phone to his ear. He was pale and weak. Virginia and Mary Jane sat nearby, crying. "How's my little star?" he asked.

"About to go on the air."

"What are you singing?"

"'Zing! Went the Strings of My Heart'"

Frank chuckled. "You've been singing that a lot lately. Maybe you should pick a new song."

"Like what?"

"Anything with swing. That's what you do best, you decide."

"Only prepared for one. Where are you?"

"I'm in the hospital."

"Why?

"They say I have spinal meningitis."

"Spinal meningitis?"

"I don't have much longer, Babe. Do you remember the times I took you girls fishing or to the fair for candy after the show, or snowball wars in the backyard?"

Baby Gumm tears up. "I'll always remember."

"I have a radio right here," he said, looking at the radio on the bedside table.

In the studio, Ethel pretended not to see the conversation, busying herself with lyric sheets.

"Daddy? Daddy? Are you there, Daddy? Hello? Daddy?"

Baby Gumm stood still for a few moments, staring off into space, a wave of grief washing over her until the Producer came over he took away the phone.

Ethel pointed to her daughter's seat by Beery. "C'mon. Over there," she demanded.

Beery leaned over the microphone, speaking in his classic radio voice. "Now, the little lady standing here beside me is only thirteen years old. Just three months ago, she signed a seven-year contract with MGM. Isn't that great? She's going to be the sensation of pictures. I take great pleasure in presenting to you Judy Garland. Alright, Judy." Sweetly and surely, she found the courage to sing.

## CHAPTER SIX

Little Church of the Flowers was monastery made of stones in the heart of Glendale, California. Votive candles burned near an open casket. People walked by, looking down, whispering final words. Ethel and the girls approached to see Frank in his double-breasted pinstripe suit and purple-checkered bow tie, looking peacefully asleep, still sporting that old mischievous smile. Frank's burial was on a windy day midway through spring. The casket sat on its grave with the tombstone reading, "Francis Avent Gumm: March 20, 1886—November 17, 1935." Underneath, an Epitaph: "Vaudeville Father, Husband and Entertainer Dancing in the Snow— And For This, We Shall Forever Cherish His Memory." Mourners surrounded the gravesite, crying, placing down flowers. Ethel and the girls held hands, unable to hold back tears. The Priest from Grand Rapids has made the trip to Glendale. He sprinkled the coffin with Holy Water, makes the Sign of the Cross and prayed.

Pattering rain accompanied a sorrowful, heartbreaking melody at home that night. Ethel was by the window, wine bottle next to her, eyes closed, violin to her chin, bowing as she strummed each note. She held the last note in a sustain, and then lowered her violin, at rest before gazing blankly out at the rainstorm, weeping harder than she's ever wept before.

## THE LION'S ROAR

The loud grunt of an animal—a lion, in fact, stretched out expansively in front of a black backdrop, caged inside a warehouse on the backlot. It was, of course, the MGM mascot, gold fur, beautiful flowing mane around its neck and chin, head sticking through a ring of film unraveled like a ribbon of gold. Piercing eyes, pupils narrowing. The motto inscribed: "ARS GRATIA ARTIS," and on both sides, "TRADE MARK." The world-renowned "METRO-GOLDWYN-MAYER" stood boldly above it. The lion roared three ferocious times. On the other side, the lion—Leo the Lion—rolled on his stomach, tied down with straps and chains around his paws and hind legs, head poking out of a circle cut in the center of a cardboard screen. A 35mm camera rolled inches from his face—the MGM logo now seen in reverse. With a film crew standing by, stones were thrown mercilessly to get one last roar.

A news headline from April 17, 1936 started it all: "MGM ADDS ANOTHER MEMBER TO FAMILY: JUDY GARLAND." The measuring tape didn't even reach five feet tall when studio executives hired hairdressers to tie her pigtails into ribbon bows and slip her tiny feet into stilettos. The white caps placed on her teeth, particularly to hide her childish buck-toothed smile, came later. When her mouth lurched over the microphone to sing, "Life is Just a Bowl of Cherries," the airwaves resonated with a richness that hadn't yet been heard. Before long, the

Gumms' put a "FOR LEASE" sign out front of The Valley Theatre. Candles flickering on fudge cakes went from fourteen to sixteen in a hurry. Virginia and Mary Jane did, in fact, get married to Bobby Sherwood and Lee Kahn, respectively. Ethel and Judy moved into a house together on 180 South McCadden Street in Los Angeles while Frank stayed in an apartment and helped with the books. As much as Judy hated MGM's schoolhouse, she was amazed by MGM's schoolhouse—her classmates' young stars such as Ava Gardner and Lana Turner. Her big break, however, came from Clark Gable and the song she sang to him at his birthday party, "Dear Mr. Gable, You Made Me Love You." In a matter of weeks, she found herself at the red carpet premiere of *Pigskin's Parade*. MGM soon casted Judy alongside Mickey Rooney in the first of several backyard musicals, beginning with *Thoroughbreds Don't Cry* and followed by a series of films released consecutively: *Broadway Melody of 1938* (a 1937 film), *Everybody Sing* (1938), *Love Finds Andy Hardy* and *Listen, Darling* (1938). Bundles of newspapers slammed down, one right after the other, film and performance reviews. Hordes of people grab from the racks. *The New York Times*—which twisted like a pinwheel in the air, blurring into a screaming headline: "RISING STARLET JUDY GARLAND!"

Blue skies and puffy clouds drifted over the Hollywoodland sign on Mount Lee. The landmark stands boldly on the hill, overlooking pine trees, Griffith Park, Beachwood Canyon Drive, Mulholland Highway. The 1930's—old-time

Hollywood. The real era of real movie stars; when the studios ruled; when the lion's roar thundered across town as if conquering the heart of a jungle; when Beverly Hills was a small town; when there weren't tourists; when there was no smog; when agents were just getting started; when you could see Sam Goldwyn and Louis B. Mayer having lox and bagels Saturdays at Nate & Al's; when you could bump into Fred Astaire, sans hairpiece, emerging from All Saints after Sunday Mass; when you could see Cary Grant drive up to the unemployment office in his Rolls to collect his thirty five dollars for the weeks he wasn't working; when Judy and Mickey Rooney knelt on the Hollywood Walk of Fame, hamming it up for the cameras as she imprinted her palm in the wet cement. Carved: "FOR MR. GRAUMAN, ALL HAPPINESS—JUDY GARLAND—10-10-39," when you could go to Malibu to see the sunset, decide to sleep on the beach and find your shoes just where you left them; when you could buy a Dusenberg for nine grand; when you could buy a mansion on Sunset Boulevard for twenty-four grand; when you could print up a business card saying you were a "producer," and fuck any girl getting off the train at Union Station.

Posh houses were dotted along the rolling Santa Monica Mountains in the Hollywood Hills. A stone walkway spiraled up the lush property of angel-shaped hedges and palm trees to a two-story Spanish colonial. The house had a crystal-clear swimming pool besieged by fountains and exotic plants. Judy floated on an inflatable duck, big sunglasses on, drinking a piña colada. Ethel

lied under an umbrella, scanning through *The Los Angeles Times*.

"These people need to get the story right. You're already a star," she snapped, flipping the pages. "We need another hit. *Camille* didn't turn out all that well. You mention that to Freed in New York."

"I heard Shirley Temple is in talks with Mr. Mayer about being traded for a film," said Judy.

"We need to talk to him about that," said Ethel. "Shirley Temple is old news. He should cast you."

Judy smiled before her inflatable duck tipped over and she fell in the water, splashing Ethel in the face.

## CHAPTER SEVEN

It was dusk when a plane touched down on the runway at the LaGuardia Airport in New York. 30 Rockefeller Plaza, an Art Deco building that stood between Fifth and Sixth Avenue, seventy stories, loomed over Midtown Manhattan. In the Rainbow Room, a lounge. Large picture windows held a view of the twinkling lights from the sixty-fourth floor. Judy and Arthur Freed sat at a table. Judy ate spaghetti and meatballs while Freed cut up his filet mignon.

"Ever been to Kansas?" asked Freed, chewing, chomping on his meal.

"Kansas? I haven't been most places, Mr. Freed. I haven't been anywhere at all."

"The girl you're playing."

"What about her?"

"Dorothy. She's from Kansas. A tornado swoops down and carries her into the Land of Oz."

"The Land of what?"

"Oz."

"Oz?"

"It's a magical place—a place of magic and witches and munchkins; of ruby slippers; of lions and tigers and bears; of men made of tin and straw; of potions; of wizards. And a road."

"A road?"

"One made of bricks. Yellow bricks."

"Oh. Why yellow?"

"It leads to the Wizard."

"The Wizard?"

"That's the title: *The Wizard of Oz.*"

Judy took this all in, smiling bright. "Well, I'll put forth my best effort."

## CHAPTER EIGHT

It began with the clacking of a typewriter. Pages followed, more and more. Phrases like "Emerald City" and "Wicked Witch" were used. It became a package bound by green strings and yellows ribbons. Wrapping paper tore apart, underneath revealing: *"The Wizard of Oz*—Written by Noel Langley, Florence Ryerson and Edgar Allan Woolf— Based on the Novel By L. Frank Baum" in bold red on splashed across the cover. As the pages turned, the reader got a glimpse of the original screenplay from 1939: "The sky is bright blue with little white clouds—with the Yellow Brick Road in foreground and hills and fields in background..."

Pencils and pens drew storyboards and sketches of scenes and characters. Pages ripped apart, beautiful artwork and designs scratched upon them. Ensemble Dorothy, Scarecrow, Tin Man, the Cowardly Lion, the Wizard, Glinda the Good Witch of the North and the Wicked Witch of the West, all etched on the Yellow Brick Road, Emerald City, Field of Poppies, brushes painted wood, and so on. Hammers slammed nails, rope unraveled, tied around steel bars. Screwdrivers twisted into floors. Clothing and props were put under sewing machines and workshop tools. Miles and miles of string, plastic, rubber, cotton, satin, burlap and silk over the course of months...a blue gingham dress being stitched together...an axe being painted silver...straw crammed into a hat...rubber ears and curly gold hair... midget shoes... magical wands... broomsticks... crystal balls... sparkly outfits.

Then came the cast in full costume. Scribbled on a chalkboard, "Judy Garland: Dorothy," with her standing before the camera. The rest followed, Ray Bolger, as the Scarecrow, Jack Haley, as the Tinman until he had an allergic reaction, and Christian Ludolf "Buddy" Ebsen Jr.
replaced him, Frank Morgan, as the Wizard, Billie Burke, as the Good Witch of the North, Margaret Hamilton, as the Wicked Witch of the West, and last but not least, Terry the Dog, as Toto.

In a warehouse somewhere, sat the three-strip Technicolor Camera, the Holy Grail of filmmaking from the Roaring Twenties to the Golden Era. Manufactured by Mitchell Camera Corporation, it offered a full spectrum color photography for motion pictures. It was a well-oiled machine engineered to capture the richness of rainbows and butterflies. The genius masterpiece had a magazine three times the width; with color filters, a beam splitter consisting of a partially reflecting surface inside a split-cube prism, and three separate rolls of black-and-white film; hence the "three-strip" reference.

Stirring, brassy music accompanied a jumble of background sounds...traffic honked, voices shouted, bells rang, radios crackled...typewriters clacked. Feet stomped. Cars screeched. Airplanes soared. Showering sparks as steam engines grounded against steel tracks. Film projectors switched on, flickering beams of light onto screens across the country. There was a news headline from February 1940: "Academy of Motion Picture Arts and Sciences."

News clippings swooped and swirled like a whirlwind of loose feathers.

The New York Times—*Babes in Arms*; The Los Angeles Times—*Gone with the Wind*; The Daily Express—*Mr. Smith Goes To Washington*; San Francisco Chronicle—*Wuthering Heights*; Chicago Tribune—*Goodbye, Mr. Chips*; The Washington Post—*Stagecoach*; USA Today—*Love Affair*; The Kansas City Star—*The Wizard of Oz*; New York Daily News—*The Rain Came*; The Guardian—*The Private Lives of Elizabeth and Essex*; Variety—*Ninotchka*; The Daily Telegraph—*Of Mice and Men*; The Wall Street Journal—*Dark Victory;* and all the articles whipped away.

# CHAPTER NINE

February 29, 1940. In a huge dressing room at the Ambassador Hotel, makeup and costume artist, Dorothy "Dottie" Ponedel, a very thin woman always in flashy dress, pearls and tassels, dabbed blush on Judy's cheeks. Judy, dressed in a low-cut denim gown, stared at her face in a vanity mirror lit by bright light bulbs. Dottie put on the finishing touches, gathered her kit and left. There was a long stretch of silence as Judy explored her soul, looking into those big, brown, hypnotizing eyes of hers. Appearing in the reflection, Klieg lights spun beautifully under a marquee: "12TH ANNUAL ACADEMY AWARDS!"

Bigger and closer, those same Klieg lights shot towards the heavens outside the hotel on 3400 Wilshire Boulevard, glowing like a palace with its Mediterranean Revival architecture. Red carpet rolled down the block where bulbs flickered and shattered from a flock of photographers. People shouted outside the ropes. Glamorous fashion - with lavish gowns, furs and jewelry. Journalists clamor to get interviews from the celebrities, all waving and posing for the flashing cameras.

On a television broadcast of the ceremony in the Cocoanut Grove Nightclub, a gleaming gold pyramid of Oscar statues circled a stage where Bob Hope stood before velvet curtains, hosting the event. Legendary stars were in attendance: Spencer Tracy, James Stewart, Vivien Leigh, Frank Capra, John Ford, Clark Gable and Bette Davis. The true Golden Age of Cinema.

"Ladies and gentlemen," announced Bob Hope. "I have the pleasure now to present a young fellow that you all know received the Juvenile Award last year. And I know he's probably one of the most popular—well he is, I think, the biggest box office name in our industry. Here is Mr. Mickey Rooney!" Applause as Mickey Rooney walked up to the podium. "Members of the Academy, ladies and gentlemen, honored guests. It's my privilege this year to present the award for the Outstanding Performance by a Juvenile Actress during the past year...Ms. Judy Garland."

Clapping and cheering. And there she was—the real Judy Garland, young and naive, the spotlight following her as she stepped up to the stage. Mickey kissed her on the cheek and handed her the Oscar. "Judy," said Mickey. "I hope you win many more of them, honey, and how about doing all of us a little favor now and sing 'Somewhere Over the Rainbow.'" The audience applauded and the music began, swelling from the speakers and drowning out the noise.

About a week later, on a fine afternoon, Judy was walking through Lot 1 and saw a rather dramatic sight of *The Wizard of Oz* sets being torn down—Emerald City and Munchkinland— props thrown in wagons, walls knocked down, flooring ripped apart. Judy walked quickly, stopping just as a worker's wheelbarrow fell over, spilling yellow bricks onto the ground and at her feet. That night, Judy was lying in bed, wide-awake, staring into the shadows.

# CHAPTER TEN—ARTIE SHAW

The MGM studios commissary was where all the movie stars ate back then—from Elizabeth Taylor to Gene Kelly to Humphrey Bogart—and was always crowded. Known for Louis B. Mayer's grandmother's recipe for chicken soup, the best. Judy appeared with Mickey. Eyes shifted to them and the chatter quieted as they walk over and sat at the corner table.

"You're the studio breadwinner now," said Mickey under his breath.

"Hardly," muttered Judy.

A waiter in a white tuxedo came by the table. "Mr. Rooney, what would you like today?"

"Let's see, I'd love to have a cheeseburger and milk, please."

"Fries?" asked the waiter.

"Yes, sir."

The waiter glanced at Judy before walking off and disappearing into the kitchen.

"They have me on a diet of chicken soup," Judy complained. "It'll be that way for the next year."

"That's odd."

Mickey pointed behind Judy's shoulder. "Look who the cat dragged in."

"Who's that?" asked Judy.

A very handsome man, suave with an aura of arrogance and sophistication, a lady-killer.

"That's Artie Shaw," said Mickey. "Music man all the way. Bandleader, composer, virtuoso clarinetist."

Artie looked over and walked up to the table.

"Artie, this is Judy," said Mickey. "Judy, Artie."

Judy gasped and tossed her hair back.

Artie smiled warmly. "Didn't know Dorothy looked so stunning in person." She smiled back.

Fireflies danced in the dark on a hilltop in the San Fernando Valley, glowing among a chorus of croaking frogs and chirping crickets. Headlights scanned the bushes as Artie's Cadillac LaSalle convertible pulled up, parking on the hill. The engine cut, Artie and Judy sat in awkward silence. "Little Frances Gumm from Grand Rapids and Arthur Arshawsky from the Lower East Side of New York," said Artie. Look where we are." Judy giggled. "Smell the wind, Judy. It's orange blossoms, fragrance from the entire San Fernando Valley." He honked the horn.

"Let me ask you," said Judy, "What's the inspiration for your music?"

"Well, I started out poor and Jewish, grew up in the heart of the Big Apple," said Artie. "I became sort of a weird, jazz-band-leading, clarinet-tooting, jitterbug-surrounded Symbol of American Youth. So I listen to the greats. Buddy Rich, Jimmie Noone, Buster Bailey. I've always strived to be even greater than the greats. When I perform at the Palomar, I always show up five hours early. I sit on the stage and listen to God speak to me. I become the orchestra. I become the bass. I become the brass and woodwinds. I become all the instruments. All the music, the whole show goes through my head from start to finish."

"Why clarinet?" asked Judy.

"Because it has the most truth and soul," explained Artie, "meaning you can win the heart of the audience with just a few notes. Much quicker than you can, say, a brass instrument or other types of woodwinds." Artie slid closer to her. "What about you? What keeps you singing?"

That was the first time the thought crossed Judy's mind. "Well, I've got this vibrato. I can't control it and it has to come out," she said "But when it comes down to it, I really don't sing because I want to. I do it for other people."

"Can't imagine that."

"I'd love to own a nursery. The only problem is I have to take care of my mother, my sisters, my contract at MGM. My mother is even on the payroll. So many depend on me. My parents worked awfully hard their whole lives, just waiting for a big break like this. I owe it to them. Most of all, I owe it to my daddy in heaven."

"You don't owe a thing to anyone," said Artie. "When the time comes, quit. But right now, you're too young. Wait for your career to build first."

Judy took a deep breath.

"Easier said than done," said Artie. "It's definitely not fair to you, that's why I say it."

"It's not. And you want to know something? I hate this business," said Judy "I hate everything about it. I'm a puppet. I feel like a slave. I have to be thin. My idea of a good time is a caramel sundae at Wil Wright's ice cream parlor in Hollywood, oodles of sauce and whipped cream. Whenever I can, I slip off and gorge myself." She paused. "I just thought of something."

"What?"

"It's you. You're the reason I'll be singing from now on."

"Really? Where is your Yellow Brick Road going? Tell me, Judy."

"It's led right to you."

He wrapped his arm around her and Judy leaned closer. Couldn't take her eyes off him.

*****************************

Artie lived in a condo on Melrose Avenue, on the west side of Hollywood. High ceilings and old furniture, stacks of unpacked cartons everywhere, the air blue with cigarette smoke. Artie and Judy were wrapped in a sheet, smoking, post coital, gazing at the crow cawing outside the window. Judy cleared her throat. "Artie, can I ask you something?"

"Anything, Baby."

"How do you think I look compared to other women? Do you think I'm beautiful? I know I'm no glamour girl."

Artie searched for the right words. "You're enchanting. You're like a Mozart symphony," he said, putting it delightfully.

"No, Artie, really..."

"You're not a classic beauty, but you're still beautiful."

"I'm not beautiful. I'm homely," she said, lowering her head.

"Judy. Don't."

"When Lana Turner or Ava Gardner walk by on set, the electricians whistle. When I walk by,

they say, 'How are you doing today, Judy?'"

"That doesn't mean anything."

"Everybody's telling me I'm getting too fat," she said. "When I sit down at a table opposite a man, all he can see is my head. My neck is short. My legs are long. To make it worse, I have a funny little nose and the face of a squashed pumpkin. I might as well have been a football player. Probably why I'm a virgin. Or was."

"What?" shouted Artie, shocked to the core.

"Yes. You're my first." Artie was taken aback.

"Mr. Mayer doesn't think I'm attractive. He calls me his 'Little Hunchback.' They didn't want to cast me as Dorothy either. They wanted Shirley Temple."

"I'm sure they're happy you starred in it now. No one could have done it better than you."

"You won an Oscar."

"I won a Juvenile Oscar," she said. "Not a real one. A bit of a joke, if you ask me."

"An Oscar nonetheless. You're shortchanging yourself. Someday you'll win another one. You're Judy Garland, no one can take that away from you. Not even MGM." He stroked her red hair, making her feel slightly better as she faced him.

She sat up and opened her mouth wide.

"*Somewhere over the rainbow, way up high/There's a land that I heard of/Once in a lullaby/Somewhere over the rainbow, skies are blue/And the dreams that you dare to dream/Really do come true/Someday I'll wish upon a star... fly/Birds fly over the rainbow/Why then, oh why can't I? If happy little bluebirds fly*

*beyond the rainbow/Why, oh why, can't I?"*
Artie clapped and she kissed him passionately.

*****************************

In one of the long Stage 1 corridors at MGM Studios, there was a click, click, click. High heels strutted ahead, echoing with each step. It was Ethel, holding a newspaper, frowning, on a mission. She stopped outside Judy's dressing room, knocked and slid the paper under the door of Judy's dressing room. Inside, Judy, who's in a bathrobe, hair in curlers, in front of the vanity mirror. Dottie is applying blush on Judy's cheeks, who's dressed in costume for "Strike Up The Band."
"One minute!" screamed Dottie.
There was another knock.
"Better see who that is," Judy asked.
Dottie goes to the door, and on the floor, the unfolded newspaper, catches her eye. Judy gets up and snatching it from her; sees a headline in bold black letters—*The Los Angeles Times*: "ARTIE SHAW ELOPES WITH LANA TURNER"
Ethel's ear, pressed closely against the door, listening intently when a bloodcurdling scream came from the other side. She turned and abruptly walked off.
Judy crumbled to the floor. "NO! NO! NO! NO! NO!"
"Judy? What's the matter?" asked Dottie. She came over and read the headline. "Artie Shaw married Lana Turner? You'll find another one, Judy. I'm so sorry."

"But I love him!" She sobbed. "How could Artie do this to me?"

"Take deep breaths," insisted Dottie.

Judy ran across the room and punched the mirror, cracking it down the center. She threw perfume bottles against the wall, shattering glass everywhere. She kicked over a chair, ripped out chunks of her hair. "I don't want to live anymore!" She picked up a comb and smashed several light bulbs, popping them out of frame one-by-one, darkening the room. In a matter of moments, she lunged past Dottie and banged her head against the wall. Again and again. Splitting a gash open on her temple, blood dripping down her face. "I'M GOING TO KILL MYSELF!"

The door swung open and Ida Koverman and Arthur Freed ran in.

"What's wrong with her?" screamed Ida.

"She's losing her mind!" screamed Dottie.

Freed looked around the room. "Give her something!"

Dottie grabbed a prescription bottle from one of the drawers, yanked off the cap and squeezed Judy's mouth, all but forcing a handful of pills down her throat.

"Swallow, Judy!" screamed Dottie.

The three of them grabbed hold of Judy, constraining her, bringing her to the floor in a blubbering heap of tears.

Dottie ran her fingers through Judy's short, red hair. "It's okay...you'll be okay...it gets better..."

"I'll never find anyone like him! NEVER! NOT EVER!" screamed Judy.

As they all exchanged looks, out of breath and shocked beyond words, a tenor bell tolled.

## CHAPTER ELEVEN—<u>DAVID ROSE</u>

Judy, magnificently a woman at nineteen, slender, lovely in a billowy gossamer white gown, stood opposite David Rose at the altar at Little Church of the West in Las Vegas. He was thirty-one, charming, short, incredibly handsome, beaming in a blue suit. Judy smiled, delighted as David slipped a sapphire diamond ring on her finger. Very much in love, they kissed.

Neon lights twinkled across the desert where the Wild West frontier was just beginning to emerge as Sin City. A crowd of tourists streamed down South Las Vegas Boulevard. The night was filled with last-ditch gamblers and a seedy population ready to serve them. Whores strapped in slick red leather and loud bumper-to-bumper traffic. For several blocks on both sides of the intersection, a stretch of snazzy new establishments on Main and Commerce Street. Pioneer Club, El Cortez Hotel and Casino, The Arizona Club ("Queen of Block 16"), The Flamingo Hotel…and the image, now split into four, shimmered out of a crystal prism of luminous green. Judy was sitting on a cushion by the window of a luxurious penthouse, staring at her ring. David sat behind her, chin on her shoulder, nuzzling her ear. They rocked back and forth a little.

"It's like I have the whole city sparkling on my finger," Judy said, a smile cracking on her lips.

"If only they knew the great Judy Garland was looking down on them."

Judy looked at him and smiled. "I wrote something for you. I'm a poet now."

She brought out a leather-bound book from her purse: Thoughts and Poems by Judy Garland. "Free verse mainly."

"Read to me," said David.

She opened the first page. "Would that my pen were tipped with a magic wand that I could but tell of my love for you, that I could but write with the surge I feel when I gaze upon your sweet face."

David grinned with adoring eyes. "Maybe we can include some of that in one of the Decca records I'm writing for us."

"One more thing..." said Judy.

"The train?"

"Yes. The 'Gar-Rose Railway' is being built as we speak. Bel-Air's only backyard railroad."

"Sweetheart, that's a dream come true for me. I don't know what to say."

"Being the biggest live steam hobbyist in the world, I figured you'd need one. You can ride it while I plant my hydrangeas."

"Does it have a caboose?" asked David.

"You bet. And a depot. Over a thousand feet of track circling the house, overlooking the Valley. It will be spectacular fairyland," said Judy with an enormous smile.

"We can ride it together. I'll put on my engineer's hat and toot the horn."

David kissed her and stood, poured two glasses of wine at the bar. There was a knock at the door. He opened it, greeted by a telegram messenger.

"Sir, I have a telegram for Ms. Judy Garland," said the messenger as he handed David a note.

David closed the door and read the Western Union telegram aloud. "Ms. Garland: It's a mystery what possessed you to travel to Vegas during our third week of shooting 'Babes on Broadway.' You have a crew of over four hundred waiting. This is not a time for nonsense games. Call before returning to Culver City immediately. Sincerely, Arthur Freed."

They started laughing, clapping their hands, hysterical for almost a full minute. Judy went to the bar and scribbled on some paper. "Dear Mr. Freed: I am so very happy to announce David and I were married this A.M. Please give me a little time and I will be back to finish the picture with one take on each scene." They hopped and bounced on the heart-shaped bed, dancing and throwing pillows.

*****************************

The Stone Canyon Road Mansion was a New England-style villa nestled in the comfort of Bel-Air, an exclusive property bordered by angel-shaped hedges, Spanish moss and brass gates. A sign posted on a white picket fence: "THE GAR-ROSE RAILWAY." A miniature steam train barreled out of a tunnel and winded around the sprawling mountainous terrain. The whistle blew as it twisted around the house. Judy and David rode in front, hands in the air.

Christmas Eve 1941. Wreaths. Glass angel figurines. Frosted cookies. Veuve Clicquot wine. Shrimp scampi, trout, turkey, mashed potatoes and gravy, slices of cheesecake. Long dining room table seated a party of twenty: Judy, David, Ethel, Virginia, Bobby Sherwood, Mary Jane, Lee Kahn, Gene Kelly, Clark Gable, Mickey Rooney, Mervyn LeRoy, Arthur Freed, Al Rosen, Ida Koverman, Roger Edens, Dottie, Frank Capra, Burton Lane, Irving Thalberg, and of course, the godfather, Mr. Mayer at the end. Chatting, laughing, glasses clink for a toast.

"Silent Night" played softly on a Victrola later that night. Flames crackled in the fireplace. A tree stood in the corner with spinning ornaments, icicle tinsels, blinking lights, a glittering star. Guests' unwrapped presents and stockings stuffed with candy canes and nutcrackers. Mayer pulled out coal from his stocking and the whole room roared with laughter.

Judy was sitting on the floor at her mother's feet. "Why can't it be like Christmas in Grand Rapids? I wish Daddy were here."

Voices hushed. Eyes looked over. Virginia and Mary Jane exchanged glances as well as David and Arthur Freed. The room waited for Ethel's response, almost embarrassed for her, but she said not a word. Minutes later, they all went back to chatting and the incident was long forgotten.

Dim, red lighting in the Palomar Ballroom. Embroidered on a banner over the stage: "CALYPSO MELODY by David Rose and His

Orchestra!" Joyous pizzicato strings with jingling sleigh bells. Below, the shadows of the orchestra in the pit. Every instrument came alive, from brass to piano to woodwinds to percussion, blowing, plucking, striking, drumming, strumming, playing each note with dramatically rhythmic movements. David directed the composition, a marvelously animated conductor and composer, humming and leaning to and fro, embodied by the beautiful music from some far chambers of his soul.

During the soaring melody, David closed his eyes, his soul left him for a moment, soon caught by Judy in one of the faraway balconies, continuing the embodiment inside her, bowing to her other half as if a final desperate measure for love, captivated to the moon. She looked down, touches her belly and grin crossed her lips.

A week later, in the den at the Stone Canyon Road house, David sifted through mail on the counter. Bills, party invitations, advertisements. He froze: United States Army. He tore open the envelope.

*SELECTIVE SERVICE SYSTEM -- ORDER TO REPORT FOR INDUCTION: You are hereby ordered to report for induction into the ARMED FORCES of the UNITED STATES at Camp Robinson, Little Rock, Arizona on August 23rd, 1942 at 0800 for forwarding to an ARMED FORCES INDUCTION STATION*

David sat in front of a grand piano on a bench with sawed-off legs, eyes shut, pounding the keys when Judy appeared, admiring him from

the doorway. "I told you destroying a piano is a crime," she said.

He stopped playing. "I like to be close to the ground." He paused, rubbing his temples. "I got drafted."

"What?" asked Judy, stunned. She crossed her arms and leaned against the wall.

"I'm going into the army."

"When?"

"The day after tomorrow."

Judy walked over and sat on the couch. David looked away, unable to face her. She began to sob, tears streaming down her cheeks. "I have something to tell you."

*****************************

Complete anarchy took over the Thalberg Building at MGM. Irving and Arthur Freed rushed down the corridor, skipping steps as they brushed past assistants and studio executives, all bumping into each other, panicked, carrying shreds of *The Los Angeles Examiner* running from room to room. Mayer sat behind his desk in his office, staring out the window at sets being built for the production of *"Madame Curie."* A knock at the door. Thalberg and Freed entered.

"I hear we have a nightmare on our hands," said Mayer.

"Yes, we do," said Thalberg, running his fingers down the wall.

"Where's Ethel?" asked Mayer.

Freed sighed. "She'll be here."

"And Judy?" asked Thalberg.

"She's not coming," said Mayer, cold as ice.

Ethel hurried in and closed the door behind her.

"Your daughter's been a bad girl, Ethel," said Mayer, blood boiling.

"Mr. Mayer, we'll take care of it," Ethel replied in a meek voice.

Mayer grabbed a copy of *The Los Angeles Examiner* from his desk, stood and paced across the room, biting his lip as he breathed heavily. 'Rumor comes straight that Judy Garland and Dave Rose are expecting a baby.' The news we most dreaded." Glaring at Ethel with one of those stares you never forget, he made a statement that shocked the room. "Actresses who play the girl-next-door with pigtails can't be pregnant."

"Certainly not," said Ethel.

"We were already in trouble when she adulterated her image by taking a husband," grumbled Mayer. "Becoming a mother? That would destroy it."

"Yes, I agree," said Ethel.

"That baby simply can't have a child!" Mayer slammed his fists down on the desk, his voice thundering. Ethel, the tough and sturdy stage mother from the North, who has seen it all, the ups and downs of showbusiness, trembled in her shoes—even Thalberg and Freed, who have seen the MGM giant lose his temper countless times, stood silent and flinched at his words.

"I'm speaking of the girl in *Little Nellie Kelly*. Do you understand what I'm saying?" asked Mayer as he sat back down in his chair.

"Yes, I do," said Ethel.

Mayer lit his pipe and blew a cloud of smoke. Freed and Thalberg exchanged glances.

"The scandal...I can't even imagine," said Thalberg.

"Already is a scandal," muttered Mayer.

Freed coughed, standing as far back towards the door as he could. "Very bad for the films. Very bad publicity. Bad in every way. Headline: "Dorothy Gale Pregnant."

"What a mess," scoffed Mayer. "First gets married, now pregnant. This isn't what we talked about when we signed her."

Freed rubbed his temples. "Where's Rose?"

"Leaving this afternoon," said Ethel.

"Wonderful." Mayer slid an envelope across his desk. "I know a physician. Dr. Finley at Cedars of Lebanon. If anyone asks, she has 'strep throat.' She goes there Thursday morning.

\*\*\*\*\*\*\*\*\*\*\*\*\*\*\*\*\*\*\*\*\*\*\*\*\*\*\*\*

Judy was on the bed, gazing forlornly out the window, watching a whirlwind of dead leaves blowing over the empty train depot on the front lawn. Ethel came in and folded her arms. "How long have you known?"

"A week or so."

"It's against your contract."

"What did Mayer say?

"He's livid."

"Surprising."

"Judy, I'm not speaking as your mother. I'm speaking as your manager. It's out of the question. You can't have it."

"Can't have it?"

"You have an appointment at Cedars of Lebanon."

Judy shook her head in disbelief.

"You can have all the babies you want in life but at the right time. This is not the right time."

"I already decided: 'Scott' if it's a boy, 'Danielle' if it's a girl."

"You are completely unfit to be a wife, let alone a mother."

"You were completely unfit to be a mother. Now look at me."

"Yes, you're a superstar."

"No, I'm a wreck. I'm a miserable mess."

Judy moved past her and ran down the spiral staircase, Ethel following her.

"Don't be cruel."

"Mother, it's the truth."

"Watch your mouth. You can't take back words. We're family. Blood is thicker than water."

"You know, I think living together is taking its toll."

"I'll move out and you stay here."

"I'll move in with David when he comes back."

"David won't be back, I promise you that.

"Daddy would be so disappointed in you. I know Mary Jane would Virginia would, too if they knew the truth."

"That's not true."

"You didn't love Daddy. You loved vaudeville."

Ethel slapped Judy, causing a flush of red on her cheek. "That's enough! MGM is telling you that you can't have a baby! How is that my fault?"

"You're losing your mind again," protested Judy.

"Because you always go along with what they say! You don't care about your own daughter! Money. Fame. That's what matters to you!"

Judy stormed into the next room and sat at the table, barely containing her anger. Ethel strode to the other side of the room. "It's bad enough you tarnished your child star image by marrying an older man."

"Burn in hell, you bitch! You're the real Wicked Witch of the West!"

"David didn't have to join the service. He could've stayed out with bone spurs in his heel. What's that tell you? That you have a supportive husband? He married you for publicity and then went overseas to get away from you! Hardly a life of harmony!"

Judy scowled, her meltdown reaching its boiling point.

"No one would want to stay married to you! You're an insane little girl!"

Out of sudden rage, Judy grabbed a saltshaker and tossed it at Ethel, whacking her in the face. Ethel, shocked, ducked as Judy threw a plate, a teacup, a bowl.

"I HATE YOU, MOM!"

"Judy, stop it!"

Judy tossed a cup.

"Stop it!" screamed Ethel.

Judy chucked a plate.

"STOP IT RIGHT NOW!"

Judy hurled a chair over the table, hitting the wall. The shelf of china tipped back and forth, about to fall.

Ethel whispered to herself in dread, "Oh, no..."

And the bureau of terra-cotta worth thousands came tumbling down, pottery and precious angel figurines flying off the shelves, the whole thing crashing onto the table with earsplitting volume, oak splintering, glass shattering, spilling across the room in disastrous shambles. Seething, Ethel lost it. She lunged forward, tackling Judy to the ground. Like two rabid dogs snapping and barking, they were out for first blood. Judy gripped Ethel's scalp, ripping out strands of black and gray hair. Ethel shrieked in pain, punching Judy in the gut and kicking her in the nose.

Judy scrambled to stand and dashed up the stairs, screaming bloody murder before jumping onto the bed and burying her head in a pillow, sobbing. Ethel stopped at the doorway, breathing hard. At the sight of it all, she suddenly saw her daughter, if only for a moment, not as a singer, not as a movie star, but as a young woman going through a rough spurt and that's all. She turned and left, quietly closing the door behind her. Judy hugged the pillow, crying, crying, crying.

*****************************

Monday morning, a black Ford pulled up to the curb at Cedars of Lebanon. Judy and Ethel were squeezed in the backseat, Roger Edens driving. All were silent, bracing to be crammed inside a cold, sordid room with the cling and clang of tools on a metal table. Shiny, silver instruments. Stirrups, thongs, needles. Dr.

Finley, a haggard, mustached physician, gestured for Judy to lie on an adjoining table against the wall. Ethel was by the door, arms crossed, tense.

"Take off your underpants and put your legs into the stirrups," ordered Dr. Finley.

Ethel looked away as Judy pulled down her skirt and panties, then lied on the table.

As Dr. Finley slipped his hands into gloves, "Okay, try to think of something else..."

# CHAPTER TWELVE

U.S.O. Tour—January 4, 1943. An American flag unraveled in the Philadelphia Navy Yard, draping over a stage as patriotic music blared over a loudspeaker. A sea of troops, thousands, watched as Judy came out and waved to the deafening applause. David appeared in uniform, kissing her on the cheek. An announcer stood next to her with a plaque. "Judy, you've given the troops outstanding performances. From New York to Los Angeles to Philadelphia, you sang your heart out. Here, the U.S.O. presents present to you, the first female in history, the rank of Honorary Corporal!" A photographer jumped forward. Judy beamed at the flash.

Judy and David sat in silence later on the train, looking out at the frozen lakes and snow rolling by. Judy lit a cigarette.
"I wrote a song for the orchestra. 'Holiday For Strings.' You'll fall in love with it," said David with a big smile.
"That's nice," said Judy, not a hint of excitement in her voice.
"I met a man named Red Skelton who hosts the *Red Skelton Show*. An entertainer. Vaudeville, burlesque, casinos, nightclubs, movies. This man is one spectacular talent. Has a radio show, asked me to become the conductor of the *Raleigh Cigarettes Program*."
An attendant walked by and handed Judy a martini. "Let me know if you need anything else."
"Thank you, we're fine."

The attendant smiled and left as Judy grabbed a bottle of Nembutal from her purse. David's eyes narrowed in on the bottle, the pills spilling out from the plastic container and tumbling into Judy's palm with a slight clatter.

"Why does the doctor keep giving you that shit?"

"I have an early flight. Need to sleep on the train," as she washed a few down with her drink.

"Quit. It turns you into a lunatic."

"David, it's over. I signed the papers."
"What?"

"We're too different, you and I. We never see each other anyway."

David began to get fidgety, unsure how to take the news. "We have a house. We have a life together. We have careers. We're supposed to share those things."

"Exactly. I have a career I need to attend to."
"So do I, but I still love you. We can make it work. You just have to try."

"You're absent. I need someone by me."

"I write you almost every day. And I'll be back, you know that."

"You have another three years."

A long moment where neither said a word.

"David, let me ask you something; did you use a rubber when we made love?"

"Yes."

"Every time?"

David looked away. By the expression on his face, she knew the answer. "We can work this out. Let's work this out."

"Goodbye, David." She stood and walked to the back of the train, leaving David speechless.

\*\*\*\*\*\*\*\*\*\*\*\*\*\*\*\*\*\*\*\*\*\*\*\*\*\*\*

Judy's face. Those big gooey eyes, dark and hypnotizing. All was quiet. Then, illuminating lights switched, beaming bright in a large vanity mirror. A hand came into view, and then another and another, the hands of make-up artists touching up every feature, every pore, every spot, every flaw, reaching for cosmetic kits with brushes, Q-tips, creams, waxes, hairspray, curling irons, powder, lipstick, eyeshadow palette, rubberized disks, removable teeth caps, eyebrow pencils, concealer.

She blinked. All the hands vanished for a moment before reappearing with more cosmetics, painting on rouge lipstick, plucking eyebrows, curling her red hair, cutting her bangs, gluing the disks on her nostrils, placing the caps on her teeth, powdering her cheeks with blush. There was a woman we haven't seen before; the girl-next-door with curly hair and a funny grin was gone—now a starlet, a fox, a masterpiece of beauty.

**LIFE MAGAZINE**
December 21, 1944

Judy's face appeared gloriously in portrait. She wore a white blouse, black skirt, a bow tied at the neck, sitting with her hands clasped at her shins, lips parted. At twenty-two, it was something new, something troubling, something sensual.

## CHAPTER THIRTEEN

The office was dark and smelled like peach cobbler. Shades down, a clock ticked. Framed pictures of beaches and mountains on the walls. Judy lied sideways on a worn leather sofa, bored, spinning a globe on the table. Dr. Ernst Simmel, a sharp German psychiatrist in his late sixties, scribbled in her file and studied her from across the room. "How's your career?"

"My career is fabulous. Don't you go to the movies? *For Me and My Gal, Girl Crazy, The Wizard of Oz, Presenting Lily Mars*—choose your flavor. It's there."

"I'm asking how you feel about it. Not how the public feels about it."

She pondered for a moment.

"I've started becoming more 'glamorous' in my pictures, so to speak, but I wish I could have more dramatic roles."

"Why don't you speak up about it?"

"Because that's what MGM wants, for me to be goofy."

"Have you ever thought about leaving MGM?"

"I can't. I'm under contract. Plus, my mother would throw a fit." She sat up and lit a cigarette.

"Who have you been with since your marriage ended?"

"Well, let's see. There's Tyrone Power, Joe Mankiewicz, Orson Welles, some others."

"All within the last six months?"

"Yes."

"Tell me about your mother."

"What about her?"

"Just tell me about her. How was she growing up, how was she with your father, their marriage, how did she treat you and your sisters, all those things."

"Well, their marriage was tumultuous, as you can imagine. My father was the one who showed us affection. Now that he's gone and my sisters are married, it's just my mother and me. Well, Virginia works as a script girl at the studio so I see her sometimes—we have lunch."

"Do you and your mother get along?"
"We fight. She's cold, selfish, brooding."
"So you're looking for something now."
"What?"
"Affection."
"Vincente showers me with affection. He spoils me. We're getting married soon."
"Is he The One?"
"He has a tyrannical power about him, an aura. And I like that."
"Are you looking forward to it?"
"Very much so. He's directing my next picture. I love him so much. He's the man of my dreams. Mr. Mayer is going to give me away."
"So everyone approves of this one, but not the last."
"Yeah, I guess. They didn't like David."
"Where else do you get affection?"
"My fans."
"Minnelli is a busy man. Fans don't give affection. They give adoration. There's a difference. And I'll bet you'll be on to the next best thing, and the next and the next. I've seen it a hundred times."

"I have often wished for just a few words of love from one man, rather than the applause of thousands of people. I have the unfortunate trait of not being able to have an affair with a man without being in love with him."

The doctor scanned her file again. "It says here you've had six doctors before me. Did they help you?"

"Obviously not."

"Have you ever been in an institution?"

"No and I don't plan on going. I have a lot of fears. No wonder I'm strange. Imagine whipping out of bed, dashing over to the doctor's office, lying down on a torn leather couch, telling my troubles to an old man who can't hear, who talks with an accent I can't understand, and then dashing to Metro to make movie love to Mickey Rooney."

"We're not trying to make you strange. We're trying to make you stable." The doctor brought out a prescription pad and scribbled quickly. "Seconal, a hundred milligrams at night. Take one. Dexedrine, ten milligrams twice a day. Never past three in the afternoon or you won't sleep." He tore off the paper and handed it to her. "And start eating more. You're too thin."

"Okay. Thank you, Dr. Simmel."

"You're welcome."

Judy grabbed her purse and left.

*****************************

Red carpet stretched for blocks as an endless stream of limousines pulled up to the curb of the Tivoli Theatre, in St. Louis. Glitzy

stars in tuxedos and gowns. The roar of the crowd was deafening. Security barked orders. Press screamed. Rope barriers were clicked to posts. Bulbs flashed. Vincente Minelli, awkward, tall and lanky, an unusually unattractive man in his late forties, walked arm-in-arm with Judy, posing for the cameras. Troupes of reporters held out microphones, shouting as photographers snapped pictures. A marquee flashed over the facade: *"MEET ME IN ST. LOUIS" PREMIERE.*

The film played before a full house, flickering on the massive screen. Scenes of Judy talking and singing to Margaret O'Brien in the window. She had never looked so winsome and sweet. The audience loved it. Sweeping across the top row were some familiar faces: Mayer, Irving Thalberg, Arthur Freed, Roger Edens, Ethel and Judy, who sat by Vincente.
"Do they like me?" she asked.
Vincente looked over at her, resting his hand on her wrist. "We all love you, Judy."

## CHAPTER FOURTEEN—<u>VINCENTE MINELLI</u>

On Evanview Drive sat a hilltop pink, stucco home, beholding a faraway view of Los Angeles. A place "away above the chimney tops," as Judy would say in later years, comfortably tucked away among the canyons and greenery. A long row of cars spiraled down the driveway and along the road. In the backyard, a five-tier wedding cake topped with plastic bride and groom figurines, vanilla frosting with toasted coconut flakes and chocolate dipped cherries, sat at the end of a long banquet table covered with lobster tail, steamed shrimp, baked clams and bread from Italian bakeries, stretching across the manicured lawn of freshly cut St. Augustine grass. Fifty cushioned folding chairs were lined up to face a New England arbor overflowing with wisteria vines in full bloom. Balloons, burning candles, a mahogany wooden bar with ice sculptures and a champagne fountain. Friends mingle around the beautiful rose garden with every imaginable color. A bell rang and the guests congregated around the courtyard, sitting in the chairs. In the two front rows: Ethel, Virginia, Mary Jane, Dottie, Irving Thalberg, Mervyn LeRoy, Ida Koverman, Al Rosen, Arthur Freed, Roger Edens and Burton Lane.

Organ music and a harp began to play. Judy, in a smoky-gray jersey with pink-pearls to match her engagement ring, walked down the aisle with Mr. Mayer on her arm. Vincente, in a three-piece pinstripe suit, stood under the arbor to greet Judy as Mr. Mayer gave her away.

Reverend William E. Roberts, sixties, of the Beverly Hills Community Church, performed the ceremony. "Friends and family, welcome and thank you for being here on this wonderful day. We are gathered together to celebrate the special love between bride and groom by joining them in marriage." He held out a wooden staff, a symbol of the solemnized union, grasped by the bride and groom. Unexpectedly, Mr. Mayer stepped forward and clutched the knob at the top of the staff. The reverend, Judy and Vincente, as well as the guests, were taken aback.

Soft murmurs and whispering before Vincente spoke, "We were now man and wife in the eyes of God, but what's more, we also had the blessing of a man upstairs who in many instilled far greater dread." Swiftly, Vincente pulled Judy close and they embraced with a certain burning passion very few can understand, kissing and spinning in circles, two love birds flying far into the angelic light of Pearly Gates. The guests rose and clapped, whistling and cheering. The applause echoed across the Valley before fading among the asphalt jungle of the City of Angels.

In the bathroom a little later, chatter from the party remained at a distance. Judy turned on the faucet, splashed her face with water, stared at her reflection in the mirror. She unzipped her purse and took out a Seconal bottle. Poured six of the little red devils in her palm.

Then, a knock on the door—followed by Vincente's booming, baritone voice: "Honey! Are you in there?"

Judy, stomach swarming with butterflies, could only let out an abrupt meager response, "Just a minute!"

"Our guests are waiting for you to cut the cake!" shouted Vincente.

"I'll be right out!"

Hesitantly, she threw the pills in the toilet and dumped the remaining ones from the bottle as well before placing the bottle back in her purse. Another knock. She turned off the faucet and flushed the toilet. Opened the door to see Vincente standing in the entryway smiling. "I thought I had a runaway bride for a moment."

She grabbed his arm and they returned to the party.

****************************

By the spring, a sedan pulled up to the curb of Cedars of Lebanon. Ethel and Vincente got out and rolled a very pregnant Judy in a wheelchair up to the entrance. Before long, a baby wailed in the arms of freckled arms of Judy, wrapped in a blanket, brown eyes, chubby cheeks, the precious face of a doll. Judy rested back in bed, holding the baby over her, gasping and crying happy tears, delighted beyond words. Vincente stood over her, stroking the newborn's fuzzy black hair. Ethel came in with purple honeysuckle flowers and placed them on the windowsill. Virginia and Mary Jane followed their mother, crying at the sight of their firstborn niece.

"Oh, my God!" screamed Virginia.

"Baby Gumm!" cried Mary Jane.

"She's not ugly like me. I'm relieved," said Vincente.

Judy rocked the baby gently in her arms until the crying stopped. "I want her name to start with an "L.""

Then, the name-bickering war began.

"How about Lisa?" asked Ethel with a shrug.

"I have an aunt named Lisa," answered Vincente.

"How about Lana?" asked Mary Jane.
"Don't like it," quipped Virginia. "Lucy?"
"No. Laila," asserted Vincente. "I like that."
"Hate it," stated Judy. "Leesa." Ethel cringed. "Awful."

"Ah, I've got it," said Judy. "George Gershwin had a song named 'Liza.'"

Everyone looked at each other and shrugged.
"Judy, the 'Z' sounds odd..."

*Liza, Liza skies are gray...*

The room went quiet as Judy stared down at baby Liza. "Liza May Minnelli. It would look so good on a marquee."

****************************

A gathering of fan magazine photographers and reporters circled the living room at Evanview Drive house, from the black marble tables with white lamps to the piano next to the bay window. Judy and Vincente sat on a chintz couch in the center, toting Liza in a pink blanket, doting on her, posing for the cameras. "She really loves the

water," said Judy. "I expect she'll be a champion swimmer!"

Bulbs flashed and people clapped, the whole room filling with laughter.

In the nursery, come middle of the night, Vincente would open the door and sneak in. Light from the hallway revealed a purple room of elephants and fairies painted across the walls. By the window, a bassinet in which Vincente leaned over, looking down at his baby Liza. She opened her eyes and smiles. As he hummed the melody of "Somewhere Over the Rainbow," she giggled and hummed along, too.

An afternoon came, a much awaited-for afternoon, where the sharks in suits needed an answer...stone terrace with a view of Hollywood, angel statues and potted plants, with vines draping over the edge. Al Rosen, Roger Edens, Arthur Freed, Vincente Minelli, Ethel and Judy sit at a large table in the afternoon haze.

"We're offering you double your salary. Six thousand a week," said Al Rosen.

Judy lit a cigarette.

"Judy, you need to get back to work," said Edens.

"It's a five-year contract. That's absurd."

"You're getting the best deal in the history of cinema," asserted Edens. "Don't miss this."

"Twenty-three films in eleven years," said Judy, reflecting.

Ethel spoke up in her snippy way of saying things, always imposing. "And do what? Go to Europe? You'll run out of money in a year. Your

daughter can't grow up there. I'm her grandmother. I have some say in the matter."

"You won't have to make more than two pictures a year this time," said Al Rosen in the calmest, smoothest way possible. "No more rushing to finish productions."

"And I'll be the director on several of your films, Judy," said Vincente gently. "We'll start off with a picture together. We work well as husband and wife, director and star."

Judy shot him a look. "Your memory has failed you, honey."

Ethel frowned. "MGM has been good to you. We've all been good to you."

"You've always said MGM was your home," said Freed.

Judy blew a cloud of smoke and looked deep into Freed's eyes, practically an evil stare. "MGM is indeed where I live, but it's not a real home. I've been raised by producers and hairdressers. Punished at a very young age. I walked alone through the awkward teenage years, cameras capturing every pimple. Broken love affairs and a failed marriage documented for the whole world to see. Pills to go up, pills to come down. Booze to keep me steady. I was born at the age of thirteen on the Metro-Goldwyn-Mayer lot. I got lost on the Yellow Brick Road. It's been like a prison. Every time I picked up a French fry or dipped a spoon into a bowl of ice cream, I was damaging a valuable corporate asset. A constant struggle. What to eat, how much to eat and how often. I remember it more vividly than anything about my childhood."

Everyone went silent. Judy blew another cloud of smoke, hesitated, then sighed deeply. "Alright. How lovely, I'm surrendering to you all."

Everyone looked at each other and smiled, all but Judy, who stubbed out her cigarette and walked back inside the house.

**"MGM legal office: Please prepare all contracts covering the services of JUDY GARLAND as an actress for five years.**
**Monday, February, 1947. Al Rosen."**

## CHAPTER FIFTEEN

By the end of three months, the skies had fallen once again. Clearly back on the booze and pills, Judy's hale and hearty appearance was withered down to a bone-thin, disastrous, sickly sight. She stomped around in a frenzy—jittery, twitching, blabbering like a mad woman, hair falling out. Liza cried in the next room while a frightened Vincente stood speechless in the doorway.

"With a few strokes of the pen, my life is back in ruins!" screamed Judy. "I regretted signing it with all my heart almost immediately! My dreams of Broadway glory destroyed!"

Vincent stepped closer to her. "Judy, you're worrying about too many things. Take a break. Go for a walk."

"And my mother has been tapping my phone line for months now! She's listening to all my conversations and reporting them to MGM!"

"Judy, I promise you she's not."

"How did they know about my phone calls?"

"They don't!"

"And this film is impossible! I can't do it!"

"Judy, this is our fourth film. I know how you work. I can guide you."

She yanked *The Pirate* screenplay off the counter and flipped manically through the pages. "Not even you can turn this into a good picture!"

"Judy, you're misinterpreting the story."

"It doesn't make sense. There are two storylines." She began tearing up the pages and throwing rolled-up paper balls at Vincente. "And I can't work with Gene Kelly again!"

Vincente finally exploded. "Judy! Your child is sleeping in the next room! Pull yourself together!"

"I am together!"

Liza's wailing grew louder as Vincente stared at Judy with disbelief, shaking his head. She stormed out.

*The Pirate* set at MGM was a massive wooden deck against a backdrop of ropes, masts and torn sails. Props of swords, spears, torches. Behind the setpiece, a broad orange screen glowed like a beautiful sunrise. Set in the Caribbean Islands in the 1830's, the production was outrageously expensive. It was in between takes, and the typical bustling of a movie set swarmed below. A crew of hundreds. Electricians, production assistants, boom operators, gaffers and grips moved about. Off to the side, dancers were dressed in tight-fit body suits. Gene Kelly and Judy could be seen in the distance rehearsing lines; Kelly in a leather pirate outfit and bandana, Judy in a white dress. Vincente walked towards the stage. "Everybody in position!"

The cast and crew went to their assigned spots. Judy and Gene Kelly stood center stage. As the Technicolor Camera careened high off the ground, angling towards the actors, the lights boomed on, illuminating the scene.

Vincente held the bullhorn. "And...Action!"

Tribal music began. Dancers spun in circles, twirling their swords. Smoke lingered in the air and bongo drums hammered loud and fast. Blaring trumpets and trombones. Gene Kelly

gripped his sword, swirling around Judy as she crawled around helplessly amidst the smoke. Then—whoosh—fire shot from the ground. Judy left character and jumped around the flames in terror. "I'M GOING TO BURN TO DEATH! THEY WANT ME TO BURN TO DEATH!"

Gene Kelly ran up to her. "What's wrong?"
"THEY'RE TRYING TO KILL ME!"

The music stopped and flames sucked back into the ground, smoke clearing the air. The dancers looked at each other and the camera operator leaned back from the lens. Producers looked up from their scripts. The assistant directors, the line producers, the best boys and dolly grips, the entire crew watched in amazement, slowly forming a circle on the stage.

"THEY WANT ME TO DIE! THEY'RE TRYING TO BURN ME! THEY'RE TRYING TO BURN ME ALIVE!"

Vincente was frozen, watching his wife have a total meltdown in front of several hundred people. He came to his senses and sprinted to Judy's aid. Up close, he saw had depleted into nothingness, twitching and grinding her teeth. "Call her doctor!"

Arthur Freed emerged from the crowd.
"Should be here any minute."

Vincente sighed. "Get Dottie from the dressing room to drive her home."

Within the hour, Dottie was driving the Ford Mercury down Sunset Boulevard with Judy slumped over drooling in the backseat, sedated, speech slurred. "You received another warning

letter before this happened," said Dottie sternly. "This doesn't help."

"Really? What did it say?"

"They threatened to fire you. Five suspensions. More than any other actress at MGM."

"Dottie, they can't do that to me. Can they?"

"If you don't go to work, yes they can. If you go wasted, they can."

"I don't think so."

"You're also way too thin. You're skinny as a rail. Even I can't hide it with make-up."

"Better than fat."

"They're paying you a hundred and fifty thousand dollars for this picture and you're expected to earn it. That means getting up in the morning. Make-up, wardrobe, hair, being ready and in the right condition. Judy, it's very simple. You'll end up in the nuthouse."

Judy had never seen Dottie like that before. She gazed out the window. "They can't do anything. I've got a contract."

"Your contract has a clause. If you won't go, or leave early, they have that right. I'm giving you a personal warning. You're a spoiled brat. Shape up."

Judy and Dr. Simmel were in his office the next day. The clock ticked. The late afternoon sunlight sliced into the room from the east window, bathing the doctor's face in orangish-yellow as he sipped on a cup of coffee. Judy pulled out a pack of Marlboros from her purse and lit a cigarette. Finally, she sat up and spoke, "They

expect the best of everything from Judy Garland. Dance and jump through hoops and do forty things at once. Put out a box office hit and be a wife and raise a child all at the same time."

"You say "Judy Garland" as if you're talking about someone else. What was your birth name?"

"Frances Gumm."

"Frances. Such a pretty name."

"You didn't know that was my real name?"

"Just wanted to hear you say it."

Dr. Simmel leaned back in his chair and folded his arms, watching her closely. "Tell me your version of what happened yesterday because I've been hearing quite a few."

"I was tired, that's all. Couldn't remember my lines."

"You've been seeing me for three years now and you don't know how to be honest. Have you been taking more than two Dexedrine a day?"

"Of course not."

"Because Dexedrine can cause paranoia.

"Really? Didn't know that."

"You're surrounded by sycophants who suck the blood out of you like a bug in the night. It's time you surround yourself with better people. Do you go to church?"

"Not since I was a little girl in Lancaster."

"Do you believe in God?"

Judy though for a moment. Nothing registered. "I don't know. I do remember one thing about church, though."

"Yeah?"

"Oh, yes. On Sundays, after church, for hours, well into the night, we would look for rabbits. I would ride around with boys as they drove around at night shooting them. The headlights would paralyze the animals in the middle of the road, and they would shoot them dead. So I went out and cuddled a baby rabbit in my lap. The tiny little thing lay trembling in my arms. Suddenly, the man next to me fired his gun and the baby rabbit quivered and died—of shock."

Dr. Simmel sighed and set the coffee cup down on his desk. "What's interesting about that story is it didn't happen to you, it happened to someone else. Perhaps your sister."

Judy puffed on her cigarette, puzzled.

"How did you know?"

"I was a colleague of Freud's. I can spot liars from halfway across the world. Do you know what he said about liars?"

"No."

"He said if we lie to ourselves, we lie to others. I cannot help you if you do not keep appointments, and I cannot help you if you continue to lie to me." Dr. Simmel rolled his eyes. "How's Liza?"

"She's cute as a kitten. I love her. So proud of her."

"How's your marriage?"

"Vincente is Vincente. Nothing's changed."

Dr. Simmel studied her—there's something else there.

"When I'm in the process of leaving a man," said Judy, "which has happened to all of us, I suppose, with our partners, I decide to sail my own course. First, you make up your mind that

you're going, then you look to break the "rules," then you look for partners to escape with, you test the boundaries, get punished a little, then your captors realize the end is near. They either let you go or they try to resist, which doesn't work. You face the outside. You're scared at first, then you take a few steps and you realize the door has closed behind you and you're on your own. It's delicious and frightening together. But you willed it, you own it. You must make it work."

Doctor and patient stared at each other for a long stretch of silence.

Later that evening, in the parlor of the Evanview Drive house, Judy skipped up the stairs and down the hall only to see the door closed to the master bedroom. Noises of shuddering and moaning. She froze and listened to the grunting and slapping. Collecting herself, she pushed the door open to witness the most perverse, obscene, lewd, heartbreaking sight a wife can see— Vincente having sweaty, aggressive sex with another man in her own bed. Both completely naked, Vincente positioned behind his black lover, who's bent on his hands and knees, thrusting as hard as he can. Judy let out a ferocious gasp just as Vincent looked over, startled to see Judy standing in the doorway. "Judy!"

She turned and dashed into the bathroom, slamming the door, locking herself inside a sprawling white space with marble floors and antique glass walls. She looked around found a wine glass near the sink. She picked it up, hurling

it on the floor, shattering glass at her feet. "I'M GOING TO KILL MYSELF!"

Suddenly, loud banging on the door from the master bedroom. Vincente, now in his underwear, pounded on the door as his lover threw on his chauffeur attire and ran out.

Vincente screamed, "Judy, open up right now!" He picked up a chair and started beating it against the door. In the bathroom, Judy picked up a shard of glass and between her gut-wrenching sobs and the loud banging, slit her wrist and the right side of her throat. On the tile...droplets of dark red...spreading...forming a small pool of blood...

# CHAPTER SIXTEEN

Welcome to the sick reality of a psychiatric ward. Las Campana Sanatorium, in Compton, California had cold, echoing walls. Footsteps. Shouting voices. Locked doors with wires on windows. Maniacal, animalistic patients looked through the glass. Sneering, lost souls. A door swung open. There was Judy being rolled on a gurney down the long hallway, bandages on her wrists and neck, strapped helplessly in a straitjacket, screaming, biting, and spitting at the staff. Two Nurses and an Orderly wheeled her into a cell. Moments later, she was free from the straitjacket. She yelled, punching the wall, tearing off her gown, ripping out strands of her hair. As if caught on fire, she dove to the ground and rolled around, bellowing, crying out, hitting herself, biting her arm. The movie star, the singer, the legend, had, nevertheless, completely lost her mind. A Doctor ran into the cell with a Nurse and two more orderlies. They put straps on her arms and legs. "Judy, if you calm down, we can take those restraints off," said the Doctor, who leaned over her only for Judy to spit in his face. Saliva dripped down his cheek.

Day turned to night. Judy awakened and vomited on herself, rolled off the bed and crawled to the door. She couldn't stand, called out weakly, "Can somebody get me some water?" No response. She crawled back to her bed, returning to the hell of withdrawal. Shaking, sweating, vomiting, crying. Her body stiffened, jerking, wrenching violently in the "clonic" seizure phase, flopping

around like a fish. This lasted for a few moments before the episode calmed and she became unconscious.

Now in a room with a bed, a desk, a lamp, Judy stared out the window, watching a hummingbird sucking the nectar out of a flower in the garden. It was a glimpse into the wild ride her life was too become. Over the next two years, Judy's life became a merry-go-round of hospitals and disastrous film productions. Healthy, vibrant, delightful, dressed like Charlie Chaplin with a missing front tooth, sang and danced to *"We're a Couple of Swells"* with Fred Astaire when her condition improved. She made a blockbuster hit, MGM's highest grossing film, the best comeback of her film career, and then down the hole she went.

*"Dear Miss Garland: "Your contract with us requires you to be prompt, comply with our instructions and perform your services conscientiously to the full extent of your ability. We desire to call your attention to the fact that on a great many occasions since the commencement of your services in 'IN THE GOOD OLD SUMMERTIME,' you were either late in arriving on the set in the morning, late in arriving on the set after lunch, or were otherwise responsible for substantial delays or curtailed production, all at great cost to MGM Studios. Any further tardiness will would result in your suspension—Thursday, March 3, 1949. Louis B. Mayer."*

*"Dear Miss Garland: You have refused to comply with our instructions to report on the set of 'ANNIE GET YOUR GUN' after lunch today and you have also advised us that you do not intend to render..."*

Judy was in bed, reading the letter, chugging an entire bottle of rum, slow, slurring, mocking, "...your services in said photoplay. This is to notify you that for good and sufficient cause and in accordance with the rights granted to us under provisions of Paragraph 12 of your contract of employment with us dated February 17, 1947. We shall refuse to pay you any compensation commencing as of September 19, 1949, and continuing until the expiration of the time which would have been reasonably required to complete the role of 'ANNIE' in the photoplay 'ANNIE GET YOUR GUN' or (should another person be engaged to portray such role) until the completion of such role by such other person—Monday, September 19, 1949. Louis B. Mayer."

Judy, floating in a bubble bath, washed a handful of Seconal down with a bottle of Merlot. The phone rang on the wall next to the tub. She picked it up. "Ms. Garland speaking."
The panicked voice of Arthur Freed on the other end of the line. "Where the fuck are you?"
"I'm not coming in. I have a migraine."
"You better come in. Get over here."
"We cast away priceless time in dreams, born of imagination, fed upon illusion and put to death by reality."
"What? Judy, you have an hour."

Click. She hung up and turned on the faucet.

By five O'clock that evening, Vincente came home from the studio, exhausted, throwing his coat on the rack in the master bedroom. He walked across the room and leaned against the bathroom door. Knocked. "Judy?" He looked down and saw water creeping out from under the door. He opened the door to see the bathroom an utter catastrophe. Completely flooded, faucet running, bathtub overflowing like a waterfall. Vincente's mouth dropped, shocked to find his beautiful Art Deco bathroom destroyed from wall to wall. He turned and saw Judy floating upside-down, head underwater. He trudged over, water splashing at his feet, and dragged her out of the tub. She was completely unconscious, limp and blue as he carried her to a dry spot in the corner, laying her on the tile. Checked her pulse: none. He rolled up his sleeves and began CPR. Pumped hard and fast on her chest, screaming aloud, "One...two...three...four...five..." He then tilted her head back and lifted her chin, pinched her nose and blew into her mouth, watching her chest rise up and down. Something caught his eye and he looked over to his right: Liza stood there wide-eyed in the doorway. "Don't come in here!" She ran away and Vincente continued CPR, pumping, pumping, pumping...

Peter Bent Brigham Hospital in Boston. ICU Room. Judy, bedridden, alarmingly frail at eighty-five pounds, was being fed glucose intravenously. Her gorgeous red hair had begun

to fall out. Of all people, none other than the great Frank Sinatra appeared in the doorway, sporting his trademark clothing—a vest, silk tie and tilted fedora. He stood beside Judy, reading a letter aloud, "As you know, you have been since sometime prior to July 12, 1948, to render the services required of you under our employment contract with you; it has become increasingly apparent over the past few weeks that your condition is such as it is unlikely that you will be able in the immediate future to render your services."

Judy snatched the letter from him and threw it aside. "Get me out of here! I can still sing!"

Sinatra rubbed her cheek. "You're going to get help and recover. You almost died, Judy. No one wants to lose you. This hospital has another unit. A luxury one, associated with Harvard. You're in the best of hands. I even brought you gifts. A brand new record player."

Judy grabbed his arm, "I don't believe it! After the money I made for those sons of bitches! Those bastards! Those lousy bastards!" Out of nowhere, a bumblebee landed on the bed near her foot, yellow, fuzzy, buzzing. She looked at it, kicked her foot and it flew away.

Hydrangeas, books, clothes, perfume, gifts from Sinatra—a luxurious bungalow in the north wing of Peter Bent Brigham Hospital. A 45-RPM record spun on a turntable: "Our Love Affair" on the label. Judy removed a clock from the wall, took out a plastic bag packed with little green Dexedrine pills, popped a few in her mouth,

swallowed, stuffed the bag behind the metal gears and places the clock back on the wall. She moved to a box on the table, pulled out an O'Hara Cocktail Dress, ran her fingers across the fabric, felt more pills sewed in the seams, folded the dress back in the box. A Nurse strode in and started rummaging through her things, searching for contraband.

"You're wasting your time," snapped Judy. "There's nothing here."

A neurologist, Dr. Augustus Rose, a charming, a calm man with a soothing voice, walked in and stood by Judy. He gave her a big smile.

Judy frowned. "Will you tell the nurse to stop with the digging?"

"It's mandatory. We search every patient's room."

"I'm not a nut. It's my body that's tired. You fools don't understand. You get so exhausted on a picture that you can't sleep and you know you must sleep because you've got to face the camera early in the morning and it's going to show up every little line on your face. I'm desperately and impossibly exhausted." Suddenly, a bee buzzes by her mouth. "Phew! Doctor, there's a bee in here!" She grabbed at the air.

Dr. Rose looked around. "I don't see anything."

"You can't see it from where you're standing. Look here."

The doctor looked again. Nothing. Then—a swarm of bees descended from the ceiling, a whole colony, buzzing loudly over Judy, flying around the room, a whirlpool of vicious insects

landing on her face and arms, attacking, stinging her over and over again. The whirring sound muted "Our Love Affair" on the record player, drowning out the song as she shrieked in terror, swatting the air, puss oozing from purple boils on her skin. Two orderlies entered the room.

Dr. Rose turned to them and yelled, "She's hallucinating! Give her Thorazine! Stat!"

The orderlies pinned her down and tied her to the bed, fastening restraints on her wrists and ankles.

The nurse dropped Judy's belongings and knelt down beside her. "Okay, Judy. Just a little poke." The Nurse poked the needle into a Thorazine vile, pulled back the plunger and drew out the liquid, then injected it into Judy's arm muscle, pressing the plunger down with her thumb, siphoning the drug into her system. Judy clenched her teeth. Muscles quickly began to paralyze. The whole room goes into excruciating slow motion as her head sluggishly drops to the bed, watching the bees zip back into a hole in the ceiling. She rolled over onto her side, bloodshot eyes lingering from one person to the other, the doctor, the Nurse, the Orderlies. She tried her damnedest to lift her head but it dropped back down like a rock. Ears resonating wildly. Dim vibrations through a tunnel of droning white noise...building...louder...everything blurring...blurring...and blurring...

In the ECT Room, there were dozens of tangled wires, metal equipment, the idling hum of machines. Electrodes were attached to Judy's forehead, a rubber ball in her mouth. Dr. Rose sat

behind a glass wall, hovering over a control device. He hit a switch—a searing jolt of electricity shot through Judy's central nervous system, the stimulus pulsating into her brain with powerful surges, shocking her to the core. Flickering streaks of light brightened the room. She gasped, convulsing, squirming on the table, whimpering, tears streaming down her face. As Dr. Rose hit the switch again, another jolt of electricity and the room was lost in the chilling echo of her scream...

It was months later when Judy sat in front of an easel, painting a snowman on the canvas. After three meals a day, no pills and a healthy sleep schedule, she finally gained weight. Sexy and perky, her charisma back. Dr. Rose came in and rested his hands on her shoulders. "How are you feeling?"

"You've done everything but a lobotomy."

"You seem better."

"I can't stand it here in Boston. It's too quiet.

"When you don't have a lot of noise around you, the noise inside you becomes overwhelming. What are you painting?"

"Just expressing my artistic side, that's all. I need to be alone."

Dr. Rose nodded and left. Judy put her paintbrush down and went by the window, looking out to see patients playing croquet on the lawn. She heard laughing, joyous voices. The sun fell below the earth and a dazzling crescent moon rose, dangling in the dark heavens. It began to snow. She felt the reminiscence of another time, years ago, when snowflakes fell like diamonds

from a black starry sky. Bundled up, Frank, Virginia, Mary Jane and Baby Gumm were in the midst of a snowball fight, taking cover behind bunkers and forts. They plopped down on their backs, waving their arms, four swans on a blanket of white forming snow angels with broad wings. The vision faded into the shadows of the room. Judy blinked, stunned and shaken, deeply haunted by the memory.

## CHAPTER SEVENTEEN

Curtains fell in Louis B. Mayer's office, slicing away layers of afternoon light until the room was dark, cast in broken shadows. Ethel, Vincente, Al Rosen, Ida Koverman, Irving Thalberg, Burton Lane and Arthur Freed sat around the long glass table in silence. Mr. Mayer flipped on a light switch, plops down in his leather chair, browsed through tabloid clippings on his desk. "Judy Garland Cuts Throat Over Lost Job," publicized *The Los Angeles Mirror*. "Judy Garland Slashes Throat After Film Row," headlined in *The Los Angeles Times*. Another with a three-page spread titled: "Hollywood Heartbreaks—Story of Fame, Fortune and Despair." He struck a match and lit his pipe. "It took a war on the Korean Peninsula to keep Judy off the front pages. This is the final straw."

"Judy is a very hysterical girl," insisted Ida. "She just needs to grow up a little, that's all."

For the first time, Ethel was desperate. Her face no longer stoic, but that of a sad puppy begging for a scrap of meat. "Give her another chance. Please. She really is improving."

Mayer shook his head in utter disbelief. "She called in sick for ninety-nine out of the hundred and thirty-five shooting days on *The Pirate*. That's beyond what any actress has done here. We doubled our costs, paying people to stand around and wait."

*Easter Parade* and *Summer Stock* were hits," said Vincente, spinning out his only half-assed example.

"I understand," said Mayer, "but she's always late. Not just thirty minutes or an hour, but several hours. Or doesn't show at all. Her weight is like a yo-yo. She walks off the set randomly. She forgets her lines. She's temperamental. She hits things. She throws tantrums like a goddamn fucking child."

Leroy butted in with anger in his voice no one has heard before from a soft-spoken man. "She gets drugs from sources she's not supposed to. Doctors, psychiatrists, hospitals, nothing has straightened her out."

"And on New Year's at my house," snarked Burton, "she raided my medicine cabinet. Wiped it clean. Empty."

Mayer tossed some medical bills on his desk. "Over two hundred grand for her hospital stays and psychiatric care. Severe retroactive penalties. We're not in the money-lending business."

"You have no legal claim for taking that penalty," insisted Vincente, "and I feel strongly enough about it that we may have to establish that point in a court of law."

Thalberg walked up to him. "You are so full of shit, Minnelli. She's trashed our finances."

Al Rosen glared at Mayer. "When one of your racehorses, Mr. Mayer, injured her leg, you had her put her to pasture for over a year until she fully healed. It would seem the same consideration could be given to the little Garland gal whose golden voice and great acting ability are worth saving perhaps as much as your horse was."

Mayer's eyes narrowed as he inhaled on his pipe, the bowl scorching like a cherry on fire. "At least ten times before she has pretended to end her life when she was in trouble with the studio. She has to want to recover. She doesn't."

"She's a spoiled princess. Waited on hand and foot," barked Burton.

Ethel straightened her composure and slicked her fingers through her stringy black hair. "Remember, she's only a girl. She's the bouncy type. She'll snap out of this in a hurry."

Mayer shook his head, furious with a violent tinge of regret. "When I signed Frances Gumm, I signed a charming little girl with a golden voice that could, and did, melt the hearts of millions all across the world. She is no longer that girl."

Ethel's blinked hard as she scoffed, and she crossed her arms. "It looks like I was a sheep invited to a hungry wolf's dinner."

"I've failed Judy," alleged Vincente, practically announcing the statement patriotically. I know I have. As her husband and her director, but this will break her. Utterly kill her."

Mayer placed his pipe in the ashtray, clasped his hands together and leaned forward. "Judy has fifty years more to live, if she obeys her doctor, and I hope she will. This is with reluctance and regret, and with the intent to serve her best interests. I tried to do everything in my power for Judy. I couldn't have done more if she had been my own daughter." And with that, he picked up his pipe again and began puffing swirling, thick clouds of charcoal-black smoke.

Fifteen years after the Gumm family first drove through the Corinthian gates on Washington Boulevard, the chapter with MGM ended, giving way for another to begin. The following day there was an airplane flying over MGM at arrival of dusk. Clouds drifted by, floating in the sapphire sky as the plane soared over the backlots, the offices, the soundstages, the studio roads and setpieces before sweeping into the skyline of Culver City with an engine that whined for miles and miles thereafter. At last, Judy was set free from the chains of the Lion.

## CHAPTER EIGHTEEN—SID LUFT

A little over eight months later, a boozy, smoky lounge called "The Little Club" in Upper East Manhattan bounced lavishly with Chinese lanterns and scorching candles where also Al Jolson crooned *"I'm Sitting on Top of the World"* on the jukebox. Picture windows showcased a pattering rainstorm with heavy traffic wheeling outside on Delancy Street. Judy was seated in a booth near the back. She obviously had put on more weight, too much weight, plump and stout with a big belly and roly-poly chin. That night, she was in disguise, unnoticed by the other patrons with a black pillbox hat tipped slyly over her face, black dress, glossy gold-colored coat, jet-black hair over boyishly cut bangs, eyebrows trimmed Oriental-like, nursing a Martini and blowing smoke rings, lost in a nightmarish daydream.

A voice, a macho-man's voice, boisterous and maddening one of those you want to throw up once you hear it at a child's baseball game. "The one and only, the great, the legend, Ms. Judy Garland." Sid Luft was standing there. Dark eyes, very handsome, bulky, charismatic, early thirties and tall, slick in a silk shirt and beige suit.

Judy's unusually quick wit faulted for a split second before—"I'm enjoying being a commoner. Don't make me come out of hiding. Now get lost.

"You have my word," he said. "May I sit down?"

"Of course."

As Sid sat across from her, he flashed her a charming grin.

"I'm Sid Luft."

"And what do you do, Mr. Luft?"

"Formerly a test pilot for Douglas Aircraft, four hundred hours in the air with the Royal Canadian Airforce, and then later a prizefighter. Nicknamed "One-Punch Luft.""

"Catchy."

"You may have read, I broke the nose of Hollywood columnist Jimmy Starr on the sidewalk right in front of the Mocambo."

"I may remember something like that."

"Now I'm a booking agent."

"Big change in occupations."

"Aren't you still married?"

"Divorce will be finalized anytime now."

"Have you ever thought about going on tour? Because I don't see you as an actress at all."

"How kind of you."

"No, I mean I see you as a performer. I think you'd be incredible on a live stage. You could really have a sterling career."

Judy rested her chin on her hands, batting her eyes.

"What would you say if I could get you into the London Palladium? Seventy grand for four weeks. Easy."

"I would say you've got some screws loose. I would die of stage fright."

"The way you talk, move, the lilt of your voice, everything about you spells 'music' and 'star.' Sid spoke with an alluring persuasive style, a lilt of twang in his speech. "Your voice would fill the theatre and bring a standing ovation."

"Perhaps."

"Who's your favorite dancer?"

"Tony DeMarco."

"Well, pretend like you're Tony DeMarco out there. Go back to your roots. You have nothing to lose."

Judy, of course, didn't want him to know, but was considering the idea.

"Just my reputation, which can't get any worse. It's been terrible. People stay away from me as though I am a leper." She raised her glass. "Cheers," and chugged down the rest of her Martini. They looked at each other and burst out laughing.

Sid was right. Judy left movie star status and became the legendary performer splashed in books across the globe. Dubbed, "The Elvis of Homosexuals" by *The Advocate*, it seemed as if she soon slipped into a world of chattering records, flickering cameras, disc jockeys, clapping hands, screeching trains, soaring airplanes, talking, roaring crowds. She got new representation at William Morris Agency and departed from NYC to London on the SS Île de France. As she and her posse walked across the gangplank, the ship wished them well, blasting its horn while the other ships in the harbor sound their sirens, spelling "J-U-D-Y" in Morse code. She soon stood on deck balcony, waving at crowds on the pier, drifting further and further away as the ocean liner sailed out to sea on its voyage to England.

Tickets were soon being collected: "GARLAND IN CONCERT"—one right after the

other, two shows a night and two matinees a week at the Palladium, an enormous coliseum with fans streaming through the doors.

*The Evening Standard*—spinning, flipping, dropping like a gunned-down plane, landing on the front page: "I doubt if Sarah Bernhardt, Jenny Lind and Vesta Tilley would ever have asked for more from their admirers…"

Performances scattered across all of Europe: Scotland, Ireland, Glasgow, Edinburgh, Manchester, Dublin, Liverpool, Birmingham.

Gossip magazine headlines followed: *"THE GREAT DEBATE: SID LUFT IS DEAD WRONG FOR JUDY"*—*"SID AND JUDY, HOLLYWOOD COUPLE"*—*"LOVE BUGS SPELL 'TROUBLE'"*

Sid and Judy stepped out of a cab in New York, confronted by people stomping down the streets of Times Square, soon kissing and laughing on a stroll in Central Park.

*The Washington Post*—"*JUDY GARLAND OPENS AT PALACE THEATRE*"

Sitting in a fan's lap, Judy sang, "On the Sunny Side of the Street." There were banners in the audience: *"GAY PRIDE," "CHRIST DIED FOR SIN," "LOVE IS LOVE."* The "rainbow flag" waved in the wind, part of the LGBT movement.

*The Los Angeles Times*—
"...disproportionate part of her nightly claque seems to be homosexual, ecstatic young men in tight trousers prancing down the aisles to toss bouquets of roses, rolling their eyes, tearing at their hair and practically levitating from their seats..."

*The Kansas City Star*—*"JUDY BREAKS ALL-TIME LONG RUN RECORD AT PALACE! 12TH TERRIFIC WEEK!"*

*The New York Times*—"After nineteen weeks and 184 performances, tour ends on February 24th to standing ovation..."

*The Great American Popular Singers*—"It was an open-throated, almost birdlike vocal production, clear, pure, resonant, innocent..."

*The Boston Globe*—"JUDY GARLAND OPENS AT PHILHARMONIC AUDITORIUM—twenty-five hundred tickets sold in one hour"

*Holiday Magazine*: "Where lay the magic? Why did we grow silent, self-forgetting, our faces lit as with so many candles, our eyes glittering with unregarded tears? Why did we call her back again and again and again, not as if she had been giving a good performance but as if she had been offering salvation...?"

*Herald & Express*—"Rainbow' Girl Finds Pot o' Gold at Curran Theatre in San Francisco"

*Newsweek*—"Judy Garland Scintillates in Philharmonic Comeback."

*****************************

After the concerts, and with a baby bump starting to show on Judy's belly, a "Just Married" sign was slapped on the back of a bumper as Sid and Judy sped down a road in Paicines, California. The wedding reception had hundreds of people at the Cocoanut Grove. Life happened fast, extremely so. November 21, 1952 at St. John's Hospital in Santa Monica, Sid held Lorna Luft, born six pounds, four ounces in the delivery room while Judy smiled up at them.

## CHAPTER NINETEEN

It was one remarkably bright afternoon in a tiny, one-story brick house that belonged to Ethel Gumm, the infamous English-born, nationally syndicated American gossip columnist, Sheilah Graham, and a photographer for the tabloid, *The Los Angeles Mirror*, sat on a worn suede coach surrounded by old records and MGM memorabilia. Sheilah scribbled down notes while the photographer snapped pictures of Ethel lying cross-legged in her recliner. At only fifty-nine, she looked not a day under seventy-five, wrinkled with much longer gray hair. With her crossed black eyes, she scowled sourly during the interview.

"What do you think about her marriage to Sid Luft?" asked Graham.

"Well," said Ethel, choosing her words carefully, yet menacingly, "I'm not surprised. I've been hoping it wouldn't happen. He's a bad guy. I couldn't tell Judy anything. She has to learn everything the hard way. She's a big girl now—thirty years old. When will she grow up?"

Graham sat up and brushed back her hair, patting her pencil on her nose. "What happened when you became estranged?"

"Judy and I never had a quarrel, she just brushed me off. If you have a daughter, don't let her sing or dance. Judy has been selfish all her life. That's my fault. I made it too easy for her. What have I done wrong? What did I do that she hates me so much?"

\*\*\*\*\*\*\*\*\*\*\*\*\*\*\*\*\*\*\*\*\*\*\*\*\*\*\*\*

In the lavish suite of a Sutton Place townhouse on the East Side of Manhattan, Judy paced furiously on a fluffy white Persian Mahal carpet in the living quarters, the spacious area complete with décor of Salvador Dalí paintings and marble Greek God statues. She was fuming, holding *The Los Angeles Mirror* in her grip; Ethel was photographed behind a desk, under the caption: "GARLAND'S MAW BLISTERS LUFT—SAYS HE IS A NO-GOODNIK."

Lorna wailed in her crib while Sid stood in the bathroom doorway, watching his wife's temper rising. Judy's voice mimicked with a sense of hilarity as she read an excerpt from the article, "While Judy Garland is busy making her 'comeback' and some twenty-five grand a week, her mother, Mrs. Ethel Gumm Gilmore, works quietly at Douglas Aircraft as a clerk for about a dollar an hour, take-home pay."

She ripped up the newspaper as Sid sat in a black leather lounge chair.

"She's insane, Judy. The public knows that. "No-Goodnik" isn't even a word."

"I hate her! I hate her so much! That hideous woman, that outrageous, awful woman!"

She's just a fucking worthless, penniless clerk at Douglas—and that's exactly where she belongs!" Her eye caught something outside the window. She looked down to see Vincente holding Liza's little hand, now seven years old, crossing Fifth Avenue to the three-story building. As they reached the foyer, Vincente pressed the intercom button and a bell buzzed. Judy went to the

intercom speaker on the far wall, pushing the button. "Yes?"

"It's me," said Vincente, voice muffled on the speaker. "Can Liza and I come up?"

Sid rose and walked away. "Tell that queer to fuck off."

"Sid, stop it," whispered Judy. "He has my baby." She spoke back into the intercom. "Okay, come up."

Midnight. Moonlight shined through the window on Judy and Sid, who were sound asleep in the bedroom; Lorna in her crib and Liza sprawled out on a mattress beside the bed. The phone rang, shattering the silence. Judy awakened and reached for the phone. "Who is this and why are you calling at this hour?"

A soft, frantic voice mumbled through the receiver, "Judy, its Virginia. Where are you?"

"I'm in Sutton Place. Where else would I be?"

"Judy, Mama's dead."

Judy froze.

"She had a heart attack in the parking lot at work. We don't know what caused it. She did have diabetes and high blood pressure but that's all we know."

"Oh, God. What about the funeral arrangements?"

"Little Church of the Flowers. Same place Daddy's service was. We'll put her to rest beside him at Forest Lawn Memorial."

For the first time in a long time, Judy became speechless.

"Judy...? Judy...? Baby Gumm, are you there...?"

"Okay. Sid and I will be there tomorrow with the kids."

"Safe travels. I love you very much."

Judy hung up and rubbed her forehead, nearly paralyzed. She walked to the window and touched the cold, smooth glass as she looked out at an expansive view of New York, the traffic, the lights, the East River. After a long moment, she began to cry, tears falling down her face like rain.

*****************************

Early Sunday morning in Little Church of the Flowers, Ethel lied in state, eyes closed, her tiny body dressed splendidly in a blue skirt and pearls around her neck and wrists, hands clutched around a bouquet of Hydrangeas on her chest. Votive candles burned around the casket, lighting up the faces of mourners coming over, peering at her, whispering final words. Judy, Virginia and Mary Jane stood together in matching black dresses, arms around each other, looking at their mother. "I didn't want her to die," whispered Judy. "This is my fault. I should have taken care of her and I didn't."

"It's useless to fret about now," said Mary Jane. "She's finally at peace."

"Judy stared off into space, as if looking back to 1935. "Maybe I fulfilled Mama's ambitions, and maybe she fulfilled hers."

Virginia walked slowly up to Ethel and stroked her hair. "She was in so much pain."

"She was a lonely and determined woman," said Judy. "I guess I'm the same way."

Ethel's restless, disgruntled soul was asleep at last.

## CHAPTER TWENTY

Judy and Sid lived in a spectacular nineteen-room stone Tudor mansion hidden in the privacy of Holmby Hills, a luxurious villa on Mapleton Drive. They were getting ready for a dinner party. Judy was wearing a glittery, sequined red dress, humming as she clipped on earrings in front of the mirror. Sid washed his face and straightened his tie, strikingly handsome in a gray flannel suit, white shirt and button-down collar. His wonderfully intense Aramis cologne wafted in the air.

"Whose house again?" asked Sid.

"Humphrey Bogart and his wife, Lauren's. Warner will be there, too. We've been talking about this for weeks."

"We go to a lot of parties, honey. It's all we do."

"They live two houses down, across from Bing Crosby. They're the ones who sent us wine for a housewarming gift."

"Oh, the *Casablanca* guy."

She sprayed on some perfume. "Yes. They're our neighbors now so behave."

*****************************

It was about nine O'clock in Humphry Bogart's "Sluggy Hollow" mansion—a 1920's adobe house—dark, Victorian, opulent with the brooding air of Dracula's castle. Beverly Hills lay like a pastel painting through the towering windows on either side of the antechamber. Classical music spun on Victrolas', a different

arrangement in every room. Lanterns flickered in every corridor, lining the walls, casting orange light. Sculptures and murals added to the feeling of a movie legend's home during the Golden Era. There was a knock, echoing in the foyer until a butler opened the door, greeting Judy and Sid. The butler took their wraps, Judy's fur coat and Sid's jacket. "Welcome. Everyone's this way," and he ushered them towards the dining room. Judy and Sid were led in by the butler. Standing around the room, the great Humphry Bogart, slight in stature, sullen, arrogant, remarkably similar to his film noir characters that underscored his legacy. In a billowy yellow dress was Bogart's wife, Lauren Bacall, the bombshell starlet, singer and model, blonde with a raspy, distinctive, voice and seductive eyes.

Jack Warner, the genius film mogul behind the Warner Bros. machine, dressed in tight charcoal-black suit, neatly trimmed, smooth as silk. He beamed warmly and opened his arms. "My shining star! The one and only Judy Garland!" He kissed her on the cheek.

Handshakes of gold rings and silver bracelets clinking together as introductions were made. They all sat down and pulled their chairs in.

"Where are the kids?" asked Lauren.

"Nanny's watching them for tonight," said Sid. "Thought it'd be a night without them pulling on our legs."

"Stephen and Leslie are across the street," said Lauren. "We got them bikes for Christmas."

"We have a trampoline," said Judy. "They're welcome to use it."

Lauren giggled. "They would love that."

"Lorna's already walking," said Judy.

Lauren's mouth dropped. "At a year old?"

"You got that right," said Judy, tickled. "And Liza, she's doing terrific in school. A straight-A student. Always has been."

A waiter in a tuxedo came to the table. "Drinks?"

"Brandy," answered Warner.

"Scotch," said Sid.

"I should never have switched," said Bogart. "Martini, please."

Judy winked. "Whiskey."

"Martini," said Lauren.

The Waiter smiled and left.

"Quite a combo," chuckled Bogart. "The problem with the world is that everyone is a few drinks behind." He lit a cigarette. "So tell me, what are you two doing in our territory?"

"New York is exhausting," sighed Judy as she lit a Marlboro. "The people are like racehorses there. They're go, go, go."

"And cold," added Sid.

"Just know one thing," said Lauren. "If the light over our front door is on, we are home and awake and a chosen few can ring the bell. I don't know if you've met the rest of our neighbors. Sinatra, Crosby, Gardner, who else honey?"

"Art Linkletter, Sammy Cahn, Gloria Grahame," said Bogart as he sipped on his Martini.

Sid smirked. "We haven't borrowed sugar from them yet."

Loud, animated laughter filled the room, nearly shaking the walls.

"Now that the concerts are over, we decided this is a better place to call home and raise a family," said Judy calmly.

Lauren propped her elbows on the table and rested her chin between her embraced fingers. "I read wonderful reviews about your tour in New York and London, Judy."

"I'm in awe, Judy," said Warner. "Who knew the little girl from MGM would become such a spectacular theater presence?"

"So true," nodded Lauren.

"As a way to cap her live show each night, I had her come down to the edge of the stage and sing 'Over the Rainbow.' It worked like a million bucks," said Sid with a giant hint of pride.

Warner turned to Judy. "You've always sung for your supper, Judy."

"I do sing for my supper, that's right."

Lauren sat up in her seat. "Sing something."

*"With my high starched-collar and my high-topped shoes/And my hair piled high upon my head/I went to lose a jolly hour on the trolley/And lost my heart..."*

Everyone clapped.

"I can't wait to see that talent in *A Star Is Born*," said Warner.

"When do you start shooting?" asked Lauren.

"Two weeks actually," replied Sid.

"We're using new technology," explained Warner. "CinemaScope, a camera with an anamorphic lens. Breathtaking wide-screen features. It's like you're actually there."

Lauren seemed genuinely in awe. "Sounds beautiful."

"Very hard to cast," said Warner. "We turned down Flynn. You know Flynn, he's either got to be fighting or fucking. We also turned down Brando and Sinatra."

"And Bogart," said Sid snidely.

There was nervous laughter as Bogart glared at him from across the table.

"Judy wanted Cary Grant," said Sid "She's always had a puppy love thing for him."

"And Luft here persuaded James Mason to play the male lead," said Warner, winking at him like Santa Claus.

"Which may not be good since I always fall in love with the leading man," said Judy.

Warner held up his brandy. "Judy's audition was superb. Fierce. The emotion, the intensity. It truly scared me."

"Oh, that's nothing," said Judy. "Come over to my house. I do it every afternoon."

"I can attest to that," said Sid, followed by another flow of laughter.

"Let's have a toast," said Warner. "To Bogart, Lauren, our children and to us with *A Star Is Born*." They all raised their glasses.

Later in the evening, there were piles of dishes with half-eaten lamb chops. Drinks were empty. Everyone was tipsy or drunk.

Bogart's head tilted when he looked at Judy, "And what made you choose this guy? This Sid...what's his name?"

"Oh, he's a schmoozer but I love him," she stated matter-of-factly.

"A woman isn't complete without a man," said Lauren. "But where do you find a man, a real man, these days?"

Bogart moaned. "All a husband has to do is to learn to say, 'Yes, dear.'" Roaring laughter as Bogart grinned. "I like a jealous wife. We get along well because we don't have illusions about each other. Wouldn't give you two cents for a dame without a temper."

"We're balanced, I should say," countered Lauren. "I love nightlife and he loves the sea. He bought a fifty-foot yacht."

Bogart lit a cigarette and blew a dense plume of smoke. "It's called the 'Santana.' Dick Powell sold it to me. Just joined the Coast Guard Temporary Reserve. Now I spend thirty weekends a year sailing, mostly around Catalina Island."

Lauren cringed. "The constant motion makes me seasick. I can't go."

"An actor needs something to stabilize his personality," explained Bogart, "something to nail down who he really is, not who he is currently pretending to be."

Sid, having stayed silent for the majority of the conversation, butted in, "When you two met, Lauren was nineteen and Bogart, how old were you?"

An exchange of shocked looks around the table. Even the Waiter, who was collecting silver trays across the broom, paused to listen.

"You were forty-four," said Sid coldly. "Nicknamed her 'baby.'" He raised his glass. "Here's to Humphrey Bogart, ladies and gentlemen. The most overrated cradle-robber in Hollywood!"

"Sid, do you sing?" asked Bogart.

"No—"

"Then how the hell do you make a living off a singer? I can tell you have no class. Even with your custom-made shirts, bespoke suits and bench-made English shoes. You never will. I heard that your amateur boxing career ended well. You got the shit beaten out of you."

"Bogey, stop it," demanded Lauren in a snapping whisper. "Mind your manners."

"I don't mind if you don't like my manners, honey. I don't like them myself. I grieve over them on long winter evenings."

Lauren rolled her eyes. "Bogey..."

Bogart continued. Bitterly. "Rose and Minnelli, they were winners. Wondering if you'll make the cut, Sid. You're as predictable as trick dice from *Casablanca.* You always turn up a lucky eleven."

"I'm no Minnelli, that's for sure," snarked Sid. "He's a queer. I'm from a rough New York neighborhood and don't put up with shit from anyone."

Judy frowned. "Sid, that's enough."

"I'm a survivor with the scars to show for it and I think that appealed to Judy," said Sid. "She needed someone to lean on, someone who wouldn't crack."

"That's 'B Movie' dialogue," scoffed Bogart.

"Bogey here is bitter being stuck as a gangster in the shadows of film noir."

"Gangster roles bought me this house. Who bought yours? You or Judy?"

Sid rose, walked with heavy feet over to Bogart and grasped him from behind, pinning both arms to his sides, lifting him up off the floor.

"Put me down, goddamn it!" shouted Bogart.

Sid kissed him on the cheek and whispered into his ear. "You and I are going to be good friends. We shouldn't needle each other because I'll split your head open, Bogey." Sid carefully placed him back down in his chair. Bogart, after a moment of shock, and everyone watching in disbelief, erupted with roaring laughter. All the guests clapped.

"What fun we have!" screamed Lauren. "We're an odd assortment! With a wild sense of the ridiculous!"

Judy stood. "I need to powder my nose."

"Down the hall, fourth door to your right," said Lauren, pointing her in the direction.

Judy took her purse and walked off.

Judy rifled through the medicine cabinet, pushed aside the Tylenol and antacids and found the goodies—morphine, Seconal, Nembutal, Dexedrine, Demerol. She unscrewed the bottles and dumped about half of each loosely into her purse before putting them back and shutting the cabinet.

While the chatter continued in the dining room, Lauren seemed to have a thought, something stewing in her mind. "I'm going to check on Judy," she said. "She wasn't feeling well earlier." Lauren got up and left, turning the corner and far down the corridor, walking with echoing footsteps, meeting Judy just as she was walking out of the restroom. Judy was startled to the core.

"Hi, Judy. Are you alright?"

"Yes, I'm fine, said Judy right when she stumbled and dropped her purse. Brilliantly colored pills and capsules, all shapes and sizes, scattered across the floor.

"Oh, no! I'm so sorry!" cried Judy.

Lauren's mouth fell to the floor, seemingly down where all the pills where.

"No, no, no, no!"

Lauren walked over and looked down at the pharmaceutical mess on the floor. "Don't worry, Judy. I'll have Bogey gather them in a bit."

"Oh, no! I'm so embarrassed! Do you hate me?" asked Judy in the most desperate tone.

"You don't need morphine unless you're in pain," stated Lauren, hands on her hips. Are you in pain?"

"Very much. My back is killing me and also my ankles from standing onstage so long, the dancing routines, not to mention my throat."

Lauren can see right through her, down to the real problem, right into her very soul. "I'll write down the name of my doctor. He treats many pain patients."

"It's no use. They won't give them to me. I'm pregnant. Sid doesn't know yet." Then, in a peculiar blend of a gentle yet accusatory voice, Judy steps forward, heels clicking gently, almost menacingly. "You take them."

"I don't abuse them, Judy. Or steal them from bathrooms. They don't land me in asylums or hospitals. It's not your body but your soul that's in trouble."

Judy said nothing. Only folded her arms and scowled before quickly changing tune and

making a sad puppy dog expression. "Don't tell anyone. Please. I'm begging you. It would ruin everything."

"It stays between us. Come on, let's go back to the party." Lauren tried to pull her along, but Judy embraced her, sobbing on her shoulder. They rocked back and forth a little, gently, as if children. Both held each other, lit by the warm lanterns flickering in the darkness of the hall.

The Cadillac cruised with reckless speed down Monte Leon Road, blowing leaves in swirls through the air. Sid was at the wheel while Judy's mind raced in the clouds, the wind gusting her gorgeous red hair. Silence on their way home before Judy spoke in a loud slur, "Slow down. The last thing we need is a ticket."

"The speed limit's forty," snarked Sid. "I'm going thirty-five."

Judy turned to him. "You know, I thought you were very rude tonight. And disrespectful. Lauren pulled me aside and said you're nothing but a crook and a thief."

"I was being playful with Bogart, you know that."

"Well, it came across as bad taste. And I could tell Mr. Warner thought so also."

"If he doesn't like me, he can go find another producer."

"Wouldn't say that too loud. He wouldn't have a hard time."

"If I'm that replaceable, he should say so. I gave him two of his leading stars. I can't imagine what else he'd want."

There was a moment of silence as the wind blew by, sweeping the car with fresh air. Sid's face went stoic, angry before Judy spoke again. This time, with the sound of a deep, crippling sadness—"Sid, I should have told you this earlier. A week ago, I went to the doctor. I'm pregnant."

Sid gasped, shocked at first and then unbelievably livid. He shook his head, filled with resentment bitterness. "What about *A Star Is Born*? We start shooting in a week."

"That's what the costume department is for. I'm not that far along."

"What about Lorna and Liza? It's already hard enough having to deal with Minnelli once or twice a week."

"He's not that bad, Sid."

"Says the one who bitches about him every single day."

Judy frowned he spit out the window. Tension seething, they looked into each other's eyes.

"You're getting an abortion."
"Absolutely not!"

Sid waved his hand. "I'll do it myself if I have to."

"It's my body."

"You can say that again. The way you gobble down food and pills".

"Fuck you, Sid!"

"When were you planning on telling me? Now? On our way home from a lunatic's party?"

"You're the lunatic, not him."

They both bit their tongues for the rest of the way home.

## CHAPTER TWENTY-ONE

Theme music grew in volume, rising...rising...rising...coming from inside the Pantages Theatre on Hollywood Boulevard—the 27th Academy Awards in 1955. Cameras craned up, down and sideways, shooting a television broadcast of the ceremony. An Oscar Statue appeared before a luxurious Art Deco auditorium packed with the entire film industry. An orchestra thundered in the pit as a standing ovation follows Charles Brackett's entrance onstage. "Fellow members of the Academy, friends everywhere this is the last act of the 'mystery play.' This is the night we find out who walked away with the prize, and if you have any fan blood in your veins, it's pounding hard."

Cameras panned the audience—Marlon Brando, Bing Crosby, Dorothy Dandridge, Jane Wyman, Humphrey Bogart, Jack Warner, James Mason, Audrey Hepburn. A round of applause swept the auditorium while an NBC crew was setting up equipment in Cedars Lebanon Hospital. Technicians laying cables along the walls and through the room, clipping on wires, connecting plugs into outlets, extension cords strung up to a television platform built outside the window, two stories high, where a camera pointed directly into the room. A TV sat in one corner, circuits opened between the Pantages and Cedars, playing the award show live, Brackett still speaking. Judy lay in bed, Sid beside her. She's had just given birth to a sleeping Joseph Wiley Luft, cradling him in her arms. Lorna, now three, and Liza, now eleven, grabbed from a banquet

table. Shrimp, caviar, sandwiches, all kinds of celebration food.

"That man over there, he'll be lying under the window," whispered Sid to the children. "The moment mommy's name will be announced, he'll pull the blinds and she'll be on camera."

Dottie dabbed blush on Judy's cheeks, whose hair was styled flawlessly, clothed in a pink peignoir. A technician attached a microphone to her collar.

"Jesus," said Judy. They're wiring me up like a radar."

Sid kissed her on the cheek. "You're a shoo-in, trust me."

"I'd hope so with all this work. Almost as much as the picture itself."

Three carpenters crawled through the window, one after the other, coils of cables lobbed over their shoulders.

"Boys, wouldn't you like a drink?" asked Judy. "You're working so hard. There's food against the wall over there."

The Director approached her. "Judy, can you move a little to the left? We can frame you better in the lens."

"Where are we? I can't see the TV."

"Mistress of Ceremonies, Thelma Ritter."

Judy rolled her eyes. "She talks and talks."

The Director handed her a three-page acceptance speech and dropped a bottle of champagne in an ice bucket next to her bed. "We'll go through a dress rehearsal soon. Keep going over your speech."

"I'm afraid if I move my head, I'll detach a wire."

"You're fine. Remember; after Betty Bacall accepts on your behalf, banter with Mr. Hope for about a minute and the music will begin. Then we're done."

"What time will we be on?"

"Best Actress will be about seven o'clock."

William Holden opened the envelope at the podium. "The Award for Best Performance by an Actress...Grace Kelly for *The Country Girl!*"

Music swelled as Grace Kelly lifted up her dress and stepped graciously up to the stage. She accepted her Oscar from Holden and beamed at the clapping audience. "The thrill of this moment keeps me from saying what I really feel. I can only say thank you with all my heart to all who made this possible for me. Thank you."

Meanwhile, in the Cedars of Lebanon Hospital, the TV was playing in the corner: Kelly extended her hand to Bob Hope before stepping offstage, receiving a standing ovation. And then, the moment of shock—the NBC crew, technicians, carpenters, Dottie, the Director, Sid, Liza and Lorna all stared at the screen in disbelief. There was whispering and hushing. Judy was busy looking over her speech, preparing for her segment. She touched her hair on both sides, brushed off some powder and tilted her head towards the window. "Are you filming?" No one answered her. Nothing but silence. "Sid, what's happening?"

The Cameraman pulled away from the lens and shook his head from the platform outside the window. Sid squeezed Judy's hand as the Director came over. "It was Grace Kelly."

"What?" asked Judy, gasping.

"Grace Kelly won," the Director said again.

Sid chucked a champagne bottle against the wall. It shattered, splashing some of the crew. "Those sonsabitches!"

The Director unclipped Judy's microphone and yelled to the crew, "Take it down, guys!"

Judy watched helplessly as the greatest disappointment of her lifetime unfolded. The NBC crew began packing up their equipment, unplugging the TV, technicians pulling out cables, carpenters climbing back through the window, dismantling the scaffolding outside. Judy, still holding Joey, heard snickering from the crew. "Boys, don't snort at me."

"That bleach blonde whore!" growled Sid. "Fuck the Academy Awards! They'd give it to a fuckin' Jap who shot up Pearl Harbor! Everyone at Paramount and Metro was rooting for Grace while that fucking Jack Warner was at odds with the Academy far before we came along. And they fucking shortened the picture beyond repair. They did nothing to lobby for us. Absolutely nothing. Forget it, darling. We have our own Academy Award." Sid popped a champagne cork and chugged down half the bottle before handing it to Judy. She chugged down the rest. "Robbery," mocked Sid.

Judy looked down at her newborn son. He slept in her arms, looking up with dark brown eyes, dimples, beautiful as can be. She kissed him on the forehead.

## CHAPTER TWENTY-TWO

By 1956, a little black box with an antenna that stood in the living room had begun to take over the country. Box office numbers tanked as the black-and-white device occupied the minds of the American people. Movies were out and television was in. CBS offered Judy a hundred thousand dollars for a string of performances in Vegas, New York and Hollywood. Roaming new territory, there was another medium to master. Broadcasting throughout the casinos, hotels, penthouses and into the ears of prostitutes walking the streets, there existed a radio show called Vegas A.M. 1703—"Rock & Roll Heaven" that dominated the airwaves of Sin City.

Ari Gottesman, the show's host, fifties, sat in the studio with Judy. She was much heavier, bloated, red in the face. Despite her appearance, she appeared to be happy, making funny faces to distract him; perching her lips, sucking her cheeks in like a fish, swirling her tongue around.

"Hello, this is Ari Gottesman from Vegas A.M. 1703 greeting you from Las Vegas. We have a very special guest today, Judy Garland, who's sticking her tongue out at me right now."

"Don't you say that or we'll start all over," teased Judy.

They both laughed.

"It's nice to see you," said Ari. "It's been a while."

"It has and it's nice to see you, too."

"So tell me, you're going to be performing at the New Frontier Hotel. This time on television, produced by CBS in their first colorized TV special

called the 'Ford Star Jubilee,' expected to draw over forty million viewers across the country."

"Yes, we'll be here on the eighth of April next year. Just two months away. I have the jitters a bit, remember I'm the original stage fright kid."

"Well, no one gets a frog in her throat or misses a note with more grace and enthusiasm than Judy Garland. I don't like to talk about people's salaries but it's been rumored you'll be the highest-paid entertainer to work in Las Vegas to date. You signed a lucrative three-year contract with CBS for engagements at the New Frontier in Vegas and the Palace in New York. How does that make you feel?"

"It makes me feel honored. If you're at home, to the millions of people watching, grab some popcorn and enjoy the music."

"Judy, I have to say, you really do look wonderful."

"Thank you, honey."

"The eighth of April, everyone. Turn on your television sets. It'll be quite the show."

April 8, 1956. At the Sahara Hotel and Casino, Sid lumbered through the door of a deluxe suite early that morning, carrying a briefcase and dragging a suitcase along on wheels. "Judy! Cab's downstairs! You ready?" Almost immediately, he spotted Judy asleep on the floor, drunk, snoring in her bathrobe. "Fuck..." He took off his coat, knelt down and shook her. No response. He lifted one of her eyelids and saw her pupil was dilated. "Goddamn you, Judy." He shook her again. "Wake up! Can you hear me?" He shook her even harder, rousing

her a bit, then dragged her across the suite and into the bathroom. He propped her up and set her on the shower floor, turning the knob. Water blasted out.

"That's freezing!" she screamed.

Sid slapped her. "We're getting paid a hundred thousand dollars for this gig and I'm not going to let you fuck this one up!"

Her face was near the drain, water beating over her eyes.

Whether it was a force from within or a miracle cast down from some kind of higher power, Judy astonishingly found herself onstage at the New Frontier Hotel that night. "Live Better Electricity" flickered on every television screen across the country with Ronald Reagan himself as the host. "Good evening," Reagan addressed the camera, "tonight, General Electric devotes its entire program to an exciting half-hour musical production starring Judy Garland."

Spotlights boomed on, crisscrossing to unveil an elaborate set of mirrors, ladders, spiral staircases and pianos on a shiny white floor. A camera swung over and pushed in on Judy, who was posed seductively with her head sideways and a tipped fedora over her eyes, wearing a black dinner jacket over a leotard, vigorous before a barrage of CBS cameras. Music began, drumming, ascending to the opening number. She picked up the microphone and sang, *"I Feel a Song Comin' On." "I feel a song comin' on/And I'm warning ya'/It's a victorious/Happy and glorious new strain! I feel a song comin' on/It's a*

*melody/Full of the laughter/Of children out after the rain!...*

Over the next three years, Judy fulfilled her performance commitments for CBS at some of the swankiest venues around Las Vegas. To name several, the Sands Hotel and Casino, Sunset Tower Hotel, the Palace Theatre, the Showboat Hotel and Casino, the Beverly Hills Hotel and the Fremont Hotel and Casino—all showcasing brilliant sets that blew fog during slow songs, flashing colorful lights to a variety of themes and those soft, velvet curtains closing at the end of every show. Night after night, fabulous concerts ensued. With the power of beautiful showmanship, spotlights washed over Judy, and for the next two hours, she was in dreamland onstage, waving her arms and crooning euphorically at the microphone; as always, she soaked up adoration like a child licking dripping maple syrup off delicious pancakes.

During their stay in Vegas, unfortunately for Mr. and Mrs. Luft, money was quickly being picked from the trees faster than they could save it. There were also affairs for both parties, and when they stayed in New York for both performances, the children had a chance to be with their mother and bond. Fighting to rid his gambling habits, Sid instead found himself entering a world of sin—gamblers swarming the casino floor, risking all their money, spinning roulette wheels, blackjack and craps tables, rolling dice, coins pouring out of slot machines.

The music, however, carried on while the rest of the madness slithered around like a venomous snake ready to strike and draw blood, twisting through hard times of sin and addictive natures.

"...*You'll hear a tuneful story/ Ringin' thru ya!/ Love and glory!/ Hallelujah!/ And now that my troubles are gone...*"

Judy and Humphrey Bogart kissed in the Sunset Tower Hotel, almost violently tearing off each other's clothes.

"...*Let those heavenly drums go on drummin'/ Cause I feel a song comin' on!/ I feel a song comin' on...*"

Sid pulled the lever on a slot machine in the Showboat Hotel and Casino.

"...*And I'm warning ya'/ It's a victorious/ Happy and glorious new strain!/ I feel a song comin' on/ It's a melody!/ Full of the laughter...*"

In the Beverly Hills Hotel, Judy and Frank Sinatra kissed, laughing, falling back onto the bed.

"...*Of children out after the rain!/ You'll hear a tuneful story / Ringin' thru ya'!...*"

Freemont Hotel and Casino. Sid at the blackjack table...13...25...27...and the dealer won time and time again; Sid losing thousands of dollars every hand, money dwindling faster than he and Judy could earn it.

"...*Love and glory!/ Hallelujah!/ And now that my troubles are gone/ Let those heavenly drums go on drummin'*"

A thrilled audience clapped and stomped their feet at the Palace Theatre. Judy sang, "Stompin' at the Savoy."

"*Savoy, the home of sweet romance/ Savoy/ It wins you at a glance/ Savoy/ Give happy feet a chance/ To dance/ Your form, just/ Like a clingy vine...*"

Judy waded in the water at Rockaway with her children, Joey, Lorna and Liza, laughing, playing, splashing each other. Vincente watched from the sandy shore under an umbrella. Later—Judy, wearing a black fedora, smiled radiantly as a photographer snapped her picture for a photo shoot. She leaned against a giant rock before jumping into the water, giggling, running into the waves.

"*...Your lips/ So warm and sweet as wine/ Your cheek/ So soft and close to mine/ Devine/ How my heart is singin'/ While the band is swingin'...*"

Horses galloped to the finish line at Brenton Park before an unruly crowd of screaming betters. Sid paced in the stands and tore up his ticket.

"*...Your lips/ So warm and sweet as wine/ Your cheek/ So soft and close to mine/ Devine/ How my heart is singin'/ While the band is swingin'...*"

Christmas season. Snowing. Judy and her kids strolled the street in Soho, Manhattan, looking at window displays of decorative wreaths and colorful lights encircling clothed mannequins, wrapped presents and diamond jewelry.

"*...Never tired of rompin' / Stompin' with you, at the Savoy / What joy / A perfect holiday /*

*Savoy / where we can glide and sway / Savoy, they'll let me stomp away..."*

Judy and her kids watched two giraffes at Central Park Zoo.

*"...With you/Savoy/Savoy/Savoy/Your form, just like a clingy vine/Your lips/So warm and sweet as wine/Your cheek/So soft and close to mine/Devine/Oh, how my heart is..."*

Judy leaned back and hit the final notes at the Palace Theatre.

*"...singin'/While the band is swingin'/Never tired of rompin'/Stompin' with you, at the/Savoy/What joy/Savoy, Savoy/They let me stomp away/With you!"*

The crowd screamed and cheered, rising to their feet in a standing ovation.

"Ladies and gentlemen, boys and girls, I'm proud to say my time with CBS has been a dream come true in so many ways. Thank you all so much, from the very bottom of my broken heart."

The next night, at the New Frontier Hotel, the audience went quiet. Muttering to each other, looking at their watches. Judy wobbled out, clearly loaded. She trembled onstage and tripped over the microphone chord. Gasps from the entire venue. Voices hushed. Suddenly, a heckler shouted from the crowd: "You're late!"

"The traffic was heavy," Judy shouted back.

"BOO!" screamed the Heckler, shaking his fist.

"Don't you boo at me!" yelled Judy.

Another heckler chimed in, "Shut your mouth, Judy! Go to hell!"

"Hey! Judy turned around and scowled at him, folding her arms and thrusting her hips like a child about to explode into a tantrum.

"That's rude!"

"I want my money back!" declared another heckler, hurling a cup filled with Coca-Cola at her, hitting her shoulder, splashing soda all over her dress. There was a low-pitched roar of boos as people threw popcorn and cups at her, the stage soon cluttered with trash.

Judy threw her hands up and shrieked at the top of her lungs, "I don't' have to sing for you people!"

A third heckler rose from his seat and cried out a vicious response, "We don't have to listen to you either!" Judy dropped the microphone and walked off the stage.

LOS ANGELES MIRROR
*GARLAND QUITS VEGAS SHOW IN A HUFF*

Judy, buried in shadows inside the bedroom of her Mapleton Drive house, curled up in a pillow as she slurred incoherently into a tape recorder—actual spoken words: "I'm outraged about many things that I've read about myself, that people have said. They've affected me deeply. Now I'm going to talk back. I'm going to talk in my own words and tell the truth, so here it goes. If I sound like the lady that protests too much...don't get the idea that by telling my story, and, I have a right to...don't think that comes from anything but by being treated badly, written about in a shocking manner, smeared, scandalized...and I'm sick of it. I've come to a time in my life when I

don't want it anymore, and I can't rise above it. I can't rise above the scandalous, obscene, the lies by the so-called 'printed word.' I can't rise above the gossip mongers...all of it has affected my children, my health and my work. By writing the truth, perhaps, the effects won't be so painful to my family and to me."

Sinatra opened the door of his suite inside the Beverly Hills Hotel, saw Judy standing there. She came in, took off her hat but left on her sunglasses.
"Take those off," said Sinatra.
"Why?"
"Because I said so. Take them off."
She took off the sunglasses, revealing a bruise under her eye, swelling to a purplish-black.
"That cheap son-of-a-bitch," snarled Sinatra. "You are done with him. I'm calling my lawyer—she stopped him, put a finger to his lips and kissed him.

Judy reclined on the couch, wiggling her toes, chatting on the phone and playing with the cord. A letter of some sort was in her hand.
"Oral sex is really healthy!" said Judy with a girlish laugh. "I'm worried about Sinatra. All he wants is blowjobs." She paused to listen. "What's wrong with that? Well, you've gotta fuck once in a while too, you know, when you're feeling frisky." She whipped her head back and laughed. "Don't get me wrong, I've been with a woman or two. When you've eaten everything in the world there is to eat, you've got to find new things,

although men are my main course." She smiled, but not quite one of happiness—almost one of mania. "Sinatra wrote me a love letter. Here, let me read it to you…'you said today that you'd been negligent. But darling, that's so unimportant compared to the great amount of happiness you've given me. I shan't forget the hours we've spent together, ever!' He's wonderful, isn't he?"

By late afternoon, Judy was facedown on the couch, an empty bottle of bourbon on the coffee table. Sid walked through the front door and passed the couch, saw her lying there. Disgusted, he scoffed and went upstairs.

An older, grayer Dr. Ernst Simmel was signing papers at his desk. The phone rang. "Dr. Simmel speaking."

Sid rubs his temples, holding the phone to his ear in the Mapleton house. "This is Sid Luft, Judy Garland's husband."

"Hello, Mr. Luft."

Sid cleared his throat and leaned against the wall, deflated. "We've never spoken before but I've heard good things about you."

"How can I help you?"

"I'm calling because, uh, I guess I don't know who else to call. She's getting worse. I need you to do something."

"She hasn't been my patient in years. I don't know what the current situation is."

"She's always drunk. Always high. I don't know where she's getting everything. I know she's on uppers, downers, opiates, everything under the sun."

"Who's her primary? Because if she's seeing multiple doctors, that's a bad sign."

"Dr. Davies."

"The first thing you need to do is search for her hiding places. Anything that's not from Dr. Davies, throw away. Alcohol, hide it from her. Don't let her leave the house until she's completely detoxified."

"What about withdrawal?"

"Give her one Seconal every four hours. You can skip the amphetamines; those are psychological, not physical. For opiates, you can't die from withdrawal but still give her one every four hours. Everything that's in capsules, pour out the powder and replace it with sugar and let her think they're real."

"The alcohol?"

"One shot every six hours. That's it."

"Alright."

"Call back if you need anything."

"Thank you, Doctor."

Sid hung up and began the search. First, he approached the window and whipped open the heavy black drapes. Light posts lining the winding driveway below illuminated the room very dimly. He ran his fingers behind the curtain, felt Scotch tape, peeled away a plastic baggie stuffed with Seconal. Several more times, peeling away more baggies, tossing them on the bed. He moved to the closet, peeked inside the pockets of her wardrobe, under the bed, in the box springs, under the rugs, inside empty perfume bottles, behind the headboard, the rich mahogany dressers, the night stands, under the lampshades. Time and time again, he stumbled

upon Seconal, Demerol, Nembutal, flasks of booze, morphine, Phenobarbital, Dexedrine, Benzedrine, Miltown, various opiates, amphetamines, barbiturates—you name it. After exhausting all possibilities, he paced across the room, confronted by baggies, envelopes and pill bottles which formed a small mountain on the bed. A submissive, troubled little voice came from behind him. Very soft, very meek—"You found them, didn't you?"

Sid turned around. Judy stood in the doorway, sipping on a vodka tonic.

"You're a gumshoe, Sid. You missed your calling. Darling, freshen up my drink."

"You fucking drunk. Drug addict".

"I'm not a—"

"You *are* a drug addict. You're fat. You're bloated. You're hideously ugly. You're a fraction of the woman you used to be. You are completely out of control."

Tears welled in her eyes.

"I'm going to flush them."

"I hate you, Sid!"

"We're broke. Totally and utterly broke." Sid's face reddened and he grimaced. "We're living on borrowed money. You made fifty-five thousand dollars a week in Vegas, more than any other artist in history. Gone. All of it."

"How...?"

"You wasted it! You canceled concerts, bought ridiculous and unnecessary things, sued CBS. The IRS is demanding twenty-one thousand dollars in back taxes. I've written fifteen thousand bad checks to cover expenses. The bank is coming down on us. You also forfeited a hundred

thousand dollars that could have easily pulled us out of debt."

"That's just a hundred grand you couldn't spend in the casino, you bastard. You throw away everything we have with the dice." She snarled in his face, "I'm filing for divorce."

"Again? The third go-around in two years? What's different this time?"

"I'm calling Jerry Geisler. The best divorce attorney in town."

"The newspapers were right—'Divorce Bug Bites Judy Garland Once Again.' What they don't know is, with all the bad things that happen, you don't fall out of love with somebody like you. If anyone tried to save you from breaking apart, I did. I know that I did the best I could and it still wasn't enough."

"Darling, we've been joined at the hip for too long. I'm trapped. I've got to get out of here." She lit a cigarette, inhaled deeply.

"Judy, we can't afford that."

"That shiny new Mercedes-Benz you have, it's your nouveau riche. Your closets are overflowing with custom made shirts, suits and shoes. You live high on my money. You bought a racehorse for eighteen grand that broke his leg, Sid. You're no saint."

"The insurance money from that horse is what covered all the bad checks. You can't even leave the state of California until you pay your taxes, Judy. That speaks for itself. You'll have to sell your jewelry and everything else. You're so far in debt, you'll never see the light of day."

"That money didn't put a dent in the debt you've put us in. Our finances are trashed,

thanks to you. I've been on stage performing night after night just to keep up with the bills. People say you steal from me and that's exactly what you do."

"Fuck them," mumbled Sid under his breath. "People believe what they want to believe."

Judy folded her arms. "You're a crook."

"Your doctors cost a fortune! You think all the prescriptions and whiskey are free? Don't tell me you don't burn through money."

"I need my doctors. You can't use that against me."

"You're only supposed to be seeing one doctor at a time. I see from your pill bottles you have at least seven."

"I'm not interested in your opinion."

"It's not just my opinion. They're right. You're the queen of all psychopathic cases. A ticking time bomb waiting to detonate at the slightest sense of uncertainty. People say you're schizophrenic. Even someone from the *Saturday Evening Post* said you have a dual identity." They said, 'She possesses personality that's split at least five ways,' if I remember correctly. He was being generous."

"You're an arrogant goon."

"You show up drunk to concerts. You can barely stand. You're unfit to take care of the kids." Sid started to move towards her, circling her like a wolf. "You're also a whore, a filthy fucking whore. Sinatra, Dean Martin, Sammy Davis Jr., Bogart. You blew the entire 'Rat Pack.' You're not the sweet little Dorothy you pretend to be. You even let your own mother die in a parking lot."

Judy slapped him across the face. "It's no secret that you fucked around, too."

Sid smacked her. She touched her flushed cheek, taken aback. He smacked her again. Harder. "Try performing with that on your face."

"How dare you!"

Sid lunged at her, tackling her to the ground, hands around her throat. He looked at her: that fat, aged, moon-like face staring back, starting to turn blue. Unexpectedly, he released his grip and kissed her. She gasped for air, breathing for a second, then kissed him back. As two dysfunctional star-crossed lovers, they stumbled across the room, wrapped in each other's arms, tearing off clothes along the way. Sid ripped off his jacket, unbuckled his belt as Judy ripped off her nightgown, dropping her underwear. He swept the baggies of pills and flasks of booze to the floor. With a beyond-complicated romance fueled by both love and fury, they jumped onto the bed and violently had sex.

## CHAPTER TWENTY-THREE

The Democratic National Convention was held in the Sports Arena Ballroom. Judy, wearing a big "JFK FOR PRESIDENT" button on her dress, Senator JFK and Jackie sat together at a banquet table for the fundraising dinner before John found himself on the front steps of the White House. He addressed the crowd:

"We observe today not a victory of party but a celebration of freedom, symbolizing an end as well as a beginning, signifying renewal as well as change. For I have sworn before you and Almighty God the same solemn oath our forebears prescribed nearly a century and three-quarters ago. The world is very different now. For man holds in his mortal hands the power to abolish all forms of human poverty and all forms of human life. And yet the same revolutionary beliefs for which our forebears fought are still at issue around the globe, the belief that the rights of man come not from the generosity of the state but from the hand of God..."

Judy, in a glittery black blazer, belted spine-chilling notes at the microphone before a full house at Carnegie Hall. She sang, "Come Rain Or Come Shine." *I'm gonna love you like nobody's loved you/Come rain or come shine/High as a mountain and deep as a river/Come rain or come shine..."*

JFK, producer Richard Adler and performers Carol Burnett and Danny Kaye shared

a laugh with Judy, who leaned on JFK's desk in the Oval Office, smoking a cigarette. "We are of Gemini duality," John. "So typical."

"Greetings, Madame Ambassador."
"Greetings, Mr. President."

JFK, awake in the Private Quarters that night beside a sleeping Jackie, picked up the phone. Dialed. Judy's voice was on the other end. "Yes, Mr. President?"
"Judy...I can't sleep."
"Mr. President, what would you like to hear?"
"I'll sing you a few bars a Capella."
"Sounds marvelous."
*"Somewhere over the rainbow, way up high/There's a land that I heard of/Once in a lullaby..."*

Judy sat with her feet dangling over the edge of the stage in a segue that only another universe could come up with. She sang, "Somewhere Over the Rainbow" in the heart of a thunderstorm. *"...Somewhere over the rainbow, skies are blue/And the dreams that you dare to dream/Really do come true/Someday I'll wish upon a star/And wake up where the clouds are far behind me/Where troubles melt like lemon drops/Way above the chimney tops/That's where you'll find me/Somewhere over the rainbow, bluebirds fly/Birds fly over the rainbow/Why then, oh why can't I?/If happy little bluebirds fly beyond the rainbow/Why, oh why can't I?"*

She opened up her arms and looked up to the heavens as an eruption of applause swept across the stadium. And, as always, even as little as a week later, there was contrast.

## CHAPTER TWENTY-FOUR

Machines beeped in Doctors' Hospital. Fluid was being drained from Judy's body as she lied nearly comatose, on the edge of death, undoubtedly in the worst shape of her life. At 4'11 and one hundred and eighty pounds, she was obese with a failing liver and swollen limbs. So weak, she could barely open her eyes, speaking so slowly that it was hard to make out words. Vincente came in and gently approached her bedside.

"Judy...it's me."

"Vincente...?"

"They're saying you can't perform. You need to take better care of yourself. The drugs, the drinking. It's time to stop."

"You know something funny? I don't care. I just don't. The pressure's off. All I care about is that I'm there for my children."

"The kids are in the hall with Sid. When you're ready, I'll have them come in to see you."

"It's nice to spend time with the kids."

"You're going to be here for seven weeks. You have hepatitis."

"But the kids—"

"The kids are fine. Judy, the doctor found some bruises on your body. Is he good to you?"

"Who?"

"Sid. Tell me the truth."

"Sid's the best..." And her voice trailed off as she fell sound asleep. Vincente stood, took one last look at her and left.

\*\*\*\*\*\*\*\*\*\*\*\*\*\*\*\*\*\*\*\*\*\*\*\*\*\*\*\*

3:19 A.M. Sid, sleepy and drunk, fighting to keep one eye open, cruised through West Hollywood in his Mercedes-Benz. Judy was asleep next him. Suddenly, a red light at the intersection. Sid tried to speed through it, slammed on the brakes—crash—rear-ending a Buick. Both vehicles rocked hard, metal crunching, glass flying. Sid got out on La Cienega Boulevard, stumbled through smoke hissing from the engine. The Buick was crushed. The Driver, scrawny, dressed in a tuxedo and red tie, got out and walked up to him. "You're drunk."

Sid had to lean against his car to stand up straight. "I'm not drunk."

"I can smell the booze from here."

A crowd started to form on the street, right outside the Nico Charisse Studio. Judy climbed out of the car and pushed through, making her way to Sid. She grabbed his arm. "Sid, we're getting out of here."

"Like hell he's going anywhere!" screamed the Driver. "He went through a red light!"

Sid yanked his arm away from Judy.

The Driver puffed out his chest. "Someone call the cops!"

Sid swung at him, busting his glasses, walloping him flat on his ass. He staggered over and kicked the Driver in the face. Bystanders gasped. A Pedestrian emerged from the crowd. "You son-of-a-bitch! You're drunk!" Sid immediately pummeled the Pedestrian in the face, dropping him to his knees. He stood over him, kicking the shit out of him until he went

unconscious, dislocating his jaw, mangling his face beyond repair. Out of nowhere, Sid was jacked in the head with a blow to the ear. Another bigger man appeared, swinging wildly at Sid, who recoiled by smashing his nose, knocking him out cold and splattering blood all over the sidewalk. Witnesses swarmed around the madness, shouting and shoving, trying to stop the brawl. Police sirens rose in the distance.

"Sid, let's go!"

A taxi pulled over on the other side of the intersection. Sid and Judy held on to each other, pushing through the hordes of people, rushing across the street. As the sirens screamed louder, they hopped inside and the cab sped away.

## CHAPTER TWENTY-FIVE

Marilyn Monroe was naked in bed, wrapped up in sheets, blabbing into the phone. "I loved JFK. I really loved him. Shame on those assassins. Now Bobby isn't the same. I'm sad. I'm scared. I'm sure what to do."

Judy's sweet voice whispered on the other end. "We're all scared, honey. I'm scared, too. I keep losing Oscars."

"At least you're nominated."

"It's overrated, trust me."

Marilyn paused for a moment, pondering, making a statement that, unbeknownst to her at the time, would make history: "I'm going to go public with my affairs with Bobby and Johnny. People need to know."

"Don't do that. They'll kill you."

"Maybe...if we could just talk more often, I know you'd understand."

"It's lonely at the top, isn't it?" asked Judy.

"Yes, it is. Very much."

Judy held the phone in her Mapleton Drive house, smoking a cigarette in bed. "Marilyn, honey, I want you to call me if you are feeling this way again. Now remember something; always be a first-rate version of yourself, instead of a second-rate version of somebody else." She gave a faint smile. "Goodnight, sweetie." She hung up and drifted off to sleep.

*****************************

Cigarette butts smoked in the ashtray, one still glowing. A breeze from the window billowed the curtains. Judy had dozed off in an upright position after her conversation with Marilyn, a drawing board on her lap where she had been tracing a landscape with crayons. The TV blared *The Tonight Show* on high volume. Then...the tip of a curtain swayed over the lit cigarette...instantly catching on fire...igniting a whoosh of smoke and flames before a hole scorched in the ceiling...the inferno spreading rapidly, blazing in hot streaks of yellow along the walls.

Before long, Sid burst out the front door with Judy in his arms, running with the kids who all screamed bloody murder.
"Sid...I wasn't done with my drawing..."
Sid put her down on the grass. "Judy, we're done. I'm filing for divorce."
As sirens from the firetrucks got louder and louder, the five of them gazed up at the crackling and popping flames.

*****************************

Judy, beyond incoherent, was hidden in the shadows of her Chateau Marmont suite, yakking into her tape recorder—another real-life recording. "Sid Luft. He's an animal. He's some kind of breed. And I'll tell the world, whenever I can, that he's a thief, a blackmailer, a sadist, and a man who doesn't care one bit, one way or the other, about any other living soul—let alone his

nice children. He's never contributed a penny to their upbringing; he's never contributed one hour to their peace of mind. He's told them how untalented they are, how stupid they are, who would need them, how he doesn't like them. How strange when an illusion dies. It's as though you've lost a child. That's not a nice man, that's a big upsetting tramp."

*******************************

Perched on a windowsill at the Mandarin Oriental, a silhouette of Judy in great detail, looking out into the distance, outlined before a panoramic view of New York City at the cusp of dawn. Icicles cloaked the window frame, trickling droplets of water, melting as the sun rose, warming the scene. The sun shined, very bright, revealing Judy as she drew the city, stroking a paintbrush across a canvas on her lap. Joey and Lorna came up and tugged on her shoulder. "What are you doing, Mama?" asked Joey.

"Painting. Want to see, kiddos?" Joey sat on her lap while Lorna leaned on her leg. "Isn't it beautiful? There's Times Square...Central Park...Tiffany's...Broadway..."

"Wow, that's really good," said Joey.

"I didn't know you could draw," said Lorna.

"I have over the years when I get inspired."

"When do we get to go home?" asked Joey.

"When we find a house, sweetie. The accident at our other house put us in quite a pickle." She sat Joey up on her lap a little more and rubbed her leg against Lorna's side. "I've been meaning to tell you two something and I'm

sorry I hadn't before but I've been a little busy. You need to know I won't always be here to protect you and watch over you. You need to know how to protect yourselves; against the newspapers, bullies, everyone. You haven't been born into a normal family or had a normal upbringing. Do you understand?"

"Yes," said Lorna.

Joey looked at her and smiled. "Mama, I understand."

"Okay, good. And remember, behind every cloud is another cloud."

## CHAPTER TWENTY-SIX

Beverly Hills, California—August 5, 1962. 4:34 A.M. The phone broke the silence. Ringing, ringing, ringing. Michael Selsman, twenty-two, publicist for Judy, Marilyn Monroe and other A-list stars, awoke. He fumbled for the phone in the dark.

"Hello."

A voice mumbled on the other end. "Marilyn Monroe is dead."

Her one-story, Hacienda-style house in Brentwood had a pool and citrus grove surrounding a guesthouse. "Cursum Perficio" tiles spread across the veranda, translating to "I Have Completed My Journey."

6 A.M. A blue Oldsmobile Cutlass pulled up the road. Selsman was met by a chaotic sight of police attempting to maintain a crime scene. The press danced on the other side of the yellow tape in a frenzy, reporters yelling and photographers flashing pictures. As described in Selsman's book, *All is Vanity*:

*"I was in front of the most famous bungalow at that moment in the world, 12305 Helena Drive, in Brentwood. It was the last house Marilyn Monroe ever lived in. And I am, by attrition, her last press agent. Her body had been wheeled, lifeless, covered with a sheet, into a coroner's van. I got to Monroe's house around six a.m. The police yellow tape was already up. It was cordoned off like a crime scene, which, later, it became. Pat Newcomb had rushed out of the house in tears, got into a car*

*and left. Dawn was now breaking over the Hollywood hills. The word was out. Reporters started arriving in droves. I stood at the tape barriers in front of the gated small house. How was I going to handle this pack of hungry reporters? The questions started flying. 'Mr. Selsman, can you tell us what happened?' 'Mike, how'd she die?' 'Was it suicide?' 'What time was the body discovered?' 'Michael, was anyone with her?' My boss had told me to give out as little information as possible, but the more I said I didn't know anything, the more the conspiracy theories started to fly about the Kennedy brothers. The public always loves tragic stories, from Jesus to Hendrix to Michael Jackson. It also helps to die young; we'll always remember JFK, Elvis, Mozart, Judy Garland and Marilyn, as they were, young and beautiful. After all, what commercial value would ninety-year-old Marilyn Monroe have today? The coroner came out, followed by the deputy D.A., John Miner. Uniformed cops and plainclothes detectives were swarming in and out of the house. This was big news, even for Hollywood. I was surrounded by reporters, who were now yelling at me for answers. It was at a time like this, heart pounding, that I wondered how I ever got into this business in the first place."*

"When I reported for duty at the Arthur P. Jacobs publicity agency, Arthur immediately handed me Mervyn LeRoy, the famous director of The Wizard of Oz, James Stewart, Henry Fonda, his son, Peter, and his daughter, Jane, Rock Hudson, Lawrence Harvey, Marlene Dietrich, Peter Sellers, Judy Garland, Steve Allen and James Mason, among others, to represent."

"Judy Garland was my all-time favorite star. She led a fractious and sad life when I knew her, but unlike Marilyn Monroe, whatever demons pursued her the night before, she was kind, generous and warm to me. As much as I disliked having to work with Monroe, that was how much I looked forward to spending time with Judy. Judy was slipping fast personally around this time. She and Sid Luft had had it out, and they were separated. Judy was depressed, doing drugs, and the last thing she wanted to do was work."

"We had interview dates to set up, and PR arrangements to make for her comeback (again) to a star-studded audience that would include all the studio heads. Everybody loved Judy, but were unsure as to her hireability, given her drugs problems, prescription and otherwise, and her fondness for champagne."

"A socko performance, which she was always capable of, but didn't always deliver, would put her back on top. Everyone wanted her to succeed. Judy deferred the details to fourteen-year-old Liza, who took notes, supervised the household staff, looked after her younger brother and sister, and made Judy's appointments with her hairdresser, her make-up people, her agents, and lawyers, their family travel arrangements, and ran interference with her stepfather, Sid Luft."

"She clearly adored her mother, and I could see why. Judy was a doting and loving parent, no doubt because she had missed out on just those qualities from her own mother and father. My heart went out to this small woman with the amazing talent that I had grown up watching and loving onscreen. Vincente Minelli, Liza's father, was one

*of MGM's top directors, and Judy fell for him because of his maturity, gentleness and grace. He was also bi-sexual, which probably surprised Judy, naïve and childish as she was, as a protected ward of the studio. Judy later married Sid Luft, a rough former bouncer, who took over Judy's management and career. She wanted someone to look out for her interests because she had outgrown MGM and was now an international star, with global travel commitments, movie, concert, recording, and stage contracts. She thought Sid was just the man she needed. It turned out that Sid had fallen into the score of his previously unsuccessful life and, tough guy that he was, intended to make the most of it. Many actresses immediately become pregnant to prove their love to their new man, and Judy sealed the deal with two more children, Lorna, and Joey. By then it was too late to get out of the marriage and her well-known depression, aided by drinking and drugs, put her once more in the awful, but oddly comfortable victim role again. Around this time, Judy had had a small but stunning comeback role in Stanley Kramer's* Judgment at Nuremberg, *in which she portrayed a Jewish concentration camp survivor, cross examined by war crimes prosecutor, Maximillian Schell. She astounded audiences with the power of her acting, but in reality, it was a role she had been playing all her life, that of victim. Once or twice, I found myself driving from Monroe's house to Judy's house on some PR function or other, and marveling at the difference in the two women. Monroe had had a hard childhood, but so did Judy. Probably a lot tougher. To me, that was part of the reason*

*emotionally lost children became actors—to live lives more agreeable to them, to wear someone else's clothes, to be called another name, to say words written for you so you wouldn't have to defend yourself at every turn, and to enter a fairytale world, at least for a while. The disparity in the two personalities was striking to me. Monroe never lost an opportunity to show you how powerful she was, and to remind you of how many people depended on her good will. She could hire you or get you fired, and made sure you knew it. Judy, on the other hand, was the perfect victim, and had been from the age of three, when she wandered out on stage during her parent's act and inducted herself into their vaudeville routine. She was always vulnerable because she never felt she could please anyone—three-year-olds stumble, or forget their lines. Judy wanted you to like her. It wasn't hard. She knew what she was, she knew what had been done to her, and she accepted it. Because she had been betrayed by her own parents, especially her mother, her habituation to authority made it impossible for her to act decisively in her own defense—except on screen. She married badly, always hoping the next man would turn out to be her prince, or salvation. In fact, many of the songs Judy made famous contained almost those very lyrics, as in The Man That Got Away.*

    *She mentioned to me that there were times she wished she were educated, that there was something else she could do for a living, but singing and acting was all she could do -she was trapped. I said I had always wanted to explore science or medicine, but that I had been corralled*

*into show business myself, and didn't see how I could leave it. She said, 'As long as you're breathing, you're always in showbiz. I'm the living example.'"*

"Her upcoming concert at the Hollywood Bowl was the major ticket in L.A. I was inundated with requests from the media, Hollywood studio executives, friends and friends I never knew I had. There was a genuinely positive mood, tinged with perhaps some trepidation you could feel in the community that she would somehow blow this 'last chance' to make it happen once more. No one needed to be concerned. That night, Judy was at the very top of her voice and personality. The weather had threatened not to cooperate, and we were concerned we might have to scrap the event because of rain in the forecast. It doesn't rain a lot in Los Angeles, and not usually in September, and the Bowl is, after all, an outdoor venue. But it wasn't raining, and a huge, sold-out audience of 20,000 filled the Bowl. They came with raincoats, scarves, hats and blankets, ready to stay even if it poured. When she walked out on a ramp over the pool, a runway deep into the audience, from which Judy could almost reach down and touch people midway through the orchestra level, the audience jumped to its feet for a long, standing ovation. 'What a nice intimate room,' she greeted everyone when she first came on stage. Then, it began to rain—a drizzle at first. But no one would dream of leaving their seat. This was a night to remember, a social as well as entertainment event. And then it rained a little harder, and I began to worry. In 1961, cordless mikes had not made their way into general usage, and Judy was working with a

*corded mike trailing a long wire. I worried some more—that the rain would somehow work into a fray or crack in the electrical cord and that Judy would, or could be electrocuted in mid-song. At one point, her cord, when it wasn't tangled around her feet, causing her to do a little dance that elicited a roar from the audience, draped itself into the pool. I thought certainly this was it—that she'd go up in a flash of lightning. A press agent's dream, even if I would miss her. It soon began to pour down, but Judy didn't quit, and neither did her audience. She had them pinned to their seats. I especially liked it when, from time to time, bands of young men scattered throughout the bowl would leap to their feet, yelling, 'Bravo, Bravo!' A good thing it was near the end of her program. She was overwhelming, and pulled shouts and mad episodes of rapturous applause from the hardened and cynical show business audience. We were by then pretty soaked, but Judy kept singing—encore after encore, until there was no way to continue. I've never felt such two-way love between a performer and an audience, before or since."*

## CHAPTER TWENTY-SEVEN

Crisp, sunny day. Birds chirped around a New England Colonial secreted by hedges and oak trees on South Rockingham Drive. Vincente walked up the steps to the front door and knocked. Judy descended the staircase in the antechamber, wearing a white robe, hearing the knock. She had become even more startlingly gaunt, very sickly, nursing a black eye with some ice as she opened the door, greeted by Vincente. She smiled.

All three kids swam in the pool while Judy and Vincente talked under an umbrella.
"I'm feeling better," said Judy. "Less tired. But I still need something easy. Something I can do and then go home and raise the children."
"That's doable." He looked at them for a moment. "They're getting big."
"Joey, especially."
"I remember when he fit in your palm."
"It feels as if it's been centuries. He's getting good grades, Lorna is too. She loves math."
"Unlike her mother. Couldn't add two and two on the MGM backlot."
Judy laughed. "I never said thank you."
"For?"
"Sticking by me over the years. I haven't been exactly a gem towards you."
"We all go through our hardships and make mistakes. I'm sorry, too. Please know that."
"It's been quite a ride."
"That it has."
"Let me ask you something. Am I a star?"

"Of course, you're a star."

"Well, then, where did everybody go? I put in a call for Frank Capra, he won't talk to me. I called Vic Fleming, he won't call back. I even called Darryl Zanuck in New York. Where'd everyone go?"

"I don't know, Judy. You're lacking direction on a personal level, for one thing."

"Liza's been the captain of my ship. And a damn good one."

"That's impressive."

"She has interview dates to set up and PR arrangements to make for my comeback."

"Another comeback?"

"You heard me."

"I guess the Hollywood Bowl wasn't enough. How much money do you have?"

"None. That's why I need to do the concerts."

They paused to watch the kids having fun, squealing, laughing, splashing.

"Liza's been wanting to sing," said Judy with a slight smile.

Vincente smiled back. "Then let her sing."

They performed at the London Palladium and on *The Judy Garland Show* at CBS Television City. Shadowy figures floated about onstage. Lights casted down on eleven dancers with sequin masquerade masks over their faces and the camera pushed between them as Judy strutted out from the wings with Liza, hands on their hips.

By then, Liza was well aware of the drug addiction and alcoholism that dogged her mother and the affect it had on her career. With the

mechanics of an assembly line, she would empty out Seconal and Dexedrine capsules in long rows, the white powder emptied out with a bag of sugar on the counter. She'd sprinkle the sugar inside the open capsules and place them back together in an effort to achieve a placebo effect but not ruin the performances. After all, Liza's name was on the project just as much as Judy's.

## CHAPTER TWENTY-EIGHT

On a moonlit night at Little Church of the West, Judy, carrying a white Bible and white rose, wearing a floor-length gold gown with jewel inlays, stood opposite Mark Herron, handsome, noticeably younger, at the altar.

"I unite you in wedlock in the name of the Father and of the Son and of the Holy Ghost. Amen," said the Priest.

"I feel like Mrs. Herron!"

"I love you," said Mark.

"I love you even more."

In a matter of months, that love dwindled down to almost nothing at all. On a private jet to London, the plane might as well have crashed and burned to do its passengers a favor.

"I HATE YOU!" screamed Judy. She threw a plate at Mark, who ducked. Lorna and Joey sat terrified by the window, hiding behind a seat. Mark threw a phone book at Judy, igniting an all-out war. She jumped forward, tackling him to the floor and scratching him repeatedly like a cat, leaving red marks all over his face.

Mark kneed her in the stomach. "You crazy bitch!"

"He hit me! He hit me!" cried Judy.

Lorna ran to intervene, arms out, standing between them like a referee at the age of thirteen. "Listen up! We need to make it to London without another fight between you two. Mark, you go to the back of the plane! Mom, go up front!"

If only one could see Mark at that moment. The face of another man trapped inside Judy's world.

Reporters rushed up to him as he walked down the steps of the courthouse a week later.

"Is it true you hit her?" one asked.

"In total self-defense."

"What caused a divorce so soon?" asked another.

"She was insane."

A third Reporter held out his microphone. "You were her third husband—"

"No, fourth. She has an addiction to marriage apparently."

Laughter. Mark got into a Ford truck and drove away.

*****************************

Judy, wasted, sprawled out on the floor, rambled into her tape recorder in the shadows. "I've laughed at myself when I should have cried! And I've cried because I've got every reason. I'm GODDAMN MAD! I'm an ANGRY LADY! I'm a lady who is angry! I've been insulted, slandered, humiliated—but still America's sweetheart! I'm not something you wind up and put on a stage that sings a Carnegie Hall album and you put it in a closet and forget to invite her to the party! There's something besides 'The Man That Got Away' or 'Somewhere Over the Rainbow' or 'The Trolley Song.' There's a woman! There are three children! There's a lot of life going here! I've always taken *The Wizard of Oz* very seriously, you

know. I believe in the idea of the rainbow. And I've spent my entire life trying to get over it. So, listeners, let me ask you…if I'm a legend, why am I so lonely?"

*****************************

The Beverly Hills Hotel. A young Barbara Walters interviewed a jittery, frail, chain-smoking Judy with Lorna and Joey sitting beside her. It was March 6, 1967. Throughout the taping, the children seemed nervous, fidgety, and uncomfortable with their mother's demeanor. Barbara tried her best to fire off the right questions but was becoming increasingly aware of Judy's state of mind. "If you hadn't been an actress or a singer, if you can imagine being anything else, what do you think you might have wanted to be?" asked Barbara.
"Happily married and, um, a nice lady."
"Do you think it's possible to be an actress and be happily married?"
"Well, I don't think anybody who married me thought so. But I think it's possible. I don't see any reason for it not to be possible. I think it's probably a little difficult. Every man I've ever met, they know that I'm Judy Garland when they start to go with me, the minute they sort of get tangled with me, they say, 'Do you know how difficult it is to be with Judy Garland?' Well, why didn't they think of that when they took me out the first time? I don't think I'm that difficult…I'm a good cook by the way." She looked at her kids. "I think you guys can vouch for that."

Joey smiled. "She makes the best Shepherd's pie."

The three of them smiled and hugged each other. Judy kissed Joey on the forehead, ashed her cigarette and lit another.

"Are there any lies you'd like to clean up?" asked Barbara. "There are things that have been said about you for years."

"Well, I think the fact that some kind of pattern of publicity started when I was very young, this, um, this business of anybody implying that I'm addicted to carpets or drinking or pills...I wouldn't have had time to learn this song if I had been as sick as they've printed me all the time. And temperamental? I haven't been able to afford to be temperamental, and I don't want to be temperamental. Now, nobody ever sues for slander, because obviously all lawyers say, 'Oh, forget it,' but the lawyer doesn't have to worry. The newspaper, the scandal sells two million copies. The front page: 'Judy Garland Admits She's Broke.' It's all in quotes by a man you've never met. They must be stopped. I want the money, I want the public apology and I want them to be taken to court...I'm not a member of the mafia; I'm not a cruel person, why should I be run over? And why should my children be subjected to that kind of thing?"

"But we have heard for years about the concerts where you couldn't appear, canceled many of them, some conversation about a television show. There are these rumors that you're difficult, very difficult."

"I'm about as difficult as a daisy."

"I heard recently that you no longer sing 'Somewhere Over the Rainbow.' I hope that's not true."

"Of course that's not true. That's the best song ever written. Who said that?"

"A reporter," said Barbara: 'Judy Garland no longer sings 'Somewhere Over the Rainbow.'"

"What does his wife do? Sing?"

"How old were you when you got your first job?"

"Thirty months and I was singing."

"Really? When you were that young? Did someone push you on the stage?"

"My mother. I sang 'Jingle Bells.'"

"And was that the beginning of your whole career?"

"Yeah. It's been a long one."

"Did you have a stage mother?"

At that word, Judy rolled her eyes. "One that wouldn't quit. My mother was truly a stage mother. A mean one. She was very jealous because she had absolutely no talent. My mother died and whenever I talk about her, and I should because she was so wicked, she inevitably knocks one earring off." She looked up. "So mother, you behave yourself." Then back to Barbara. "She would sort of stand in the wings and if I didn't feel good, if I was sick to my tummy, she'd say, 'You go out and sing or I'll wrap you around the bedpost and break you off short.' So I'd go out and sing."

## CHAPTER TWENTY-NINE

Throngs of reporters and photographers surrounded Judy and her new groom at the Chelsea Registry Office. Mickey Deans, another dashing young man she had caught by the tail. They pushed through the crowd, crossing the street arm-and-arm. Judy was drunk, stumbling by the curb while Mickey looked startled by the flurry of attention, blinded by an assault of flickering cameras. The police struggled to contain the crowd as Judy wrapped her arm around Mickey, who grinned blankly. Flashbulbs popped in front of them, a solid wall of dazzling light.

"I finally got the right man to ask me," said Judy as they got into the back of a Bentley. She threw on A hat and large sunglasses. The paparazzi swarmed every side of the car, holding their cameras up to the window. She did nothing but rest her head on Mickey's shoulder.

*****************************

"And I don't want to die. I've never met a cast of people I want to die with. You go around on an airplane and look around at people reading the *Reader's Digest* or whatever. You don't want to die with them. I get top billing. 'Judy Garland Dies In Plane Crash'—the other deceased will be in Section B, page eighteen. This is peculiar but what are we doing flying around in airplanes? We're not—even the birds don't go up that high. We just don't belong. We have to buckle ourselves in and there's no hope and no oxygen. We don't

belong up there. You know we don't belong up there. At least I don't understand. I have to make friends with the pilot where I give his children my autograph—forget it! His life isn't NEARLY as important as my life! Sheer selfishness. I don't really care. My number is up. I want a new one. I have no intention of hanging out. Now this machine isn't going to get me either. One way or another we're gonna overcome it. I've never looked through a keyhole without finding someone was looking back. I have felt the wind of the wing of madness! How long do people want to hear 'Somewhere Over the Rainbow?' So don't give me that 'the show must go on' shit."

## CHAPTER THIRTY

Dottie closed the door and the roar of the crowd could be heard from outside in the great Falkoner Center. She went to Judy sitting in the chair, rubbing the fabric on her flashy black gown. "They're waiting for you," whispered Dottie.

Judy couldn't stop staring at herself in the mirror. She was wrinkled and pale; a far cry from her heyday. Mickey Deans came in. "You look gorgeous. Time to go."

Black velvet curtains rose as the overture began...dom, dom, dom, dom...the house lights came up...the orchestra swelling in the pit, preparing for a phenomenal event. Floodlights flashed on one bank at a time from the back, igniting a deafening wave of booms. Judy waited for her cue in the wings before coming out and throwing up her arms. "Let's have a show!"

The auditorium shook with screaming and cheering. "And I'll keep singing until the roof falls in!" She put out a trembling hand and gripped the microphone, bending over for the opening number for yet another show, what would be her last.

\*\*\*\*\*\*\*\*\*\*\*\*\*\*\*\*\*\*\*\*\*\*\*\*\*\*\*\*\*

Chelsea, London—June 22, 1969. The hum of droning wind and honking horns wafted in the thick morning air. Traffic bustled down a maze of slick winding streets in the fog and drizzling rain. Black crows soared under purple clouds blooming on the horizon, cawing, flitting and fluttering over rooftops, casting shadows on an

affluent district of cottages curling through the Royal Borough. Inside one of the bungalows, far beyond the hill, beams of sunlight sliced through a window where a sweeping view of Greater London laid beyond parted suede curtains. Silhouettes peeled away to unveil the blinking of stoplights, cars crossing Putney Bridge, umbrellas walloping open, ferries sailing Chelsea Harbour, trains roaring underground in Sloane Square Station, smoke lingering from chimneys. The scope of it all was bound by Knightsbridge and the River Thames. Beautiful, picturesque, the city sparkled, unmasked by the flush of dawn. And maybe, far, far in the distance, a rainbow.

There was a gust of wind as a crow swooped down, landing in a straw nest on the windowsill, eyes darting about, peeking inside, narrowing in on a cold and quiet bathroom with a tub half-full of water. Below a tall oval mirror, the vanity was a disastrous sight; a hairbrush in the sink, make-up, eyeliner knocked over, perfume, gold jewelry, cigarette butts, wet towels and clothes strewn about. On the floor, a shattered wine glass and two-dozen pills, red capsules scattered across the white marble tile. A prescription bottle rolled by, stopping before thin strands of graying red hair: "JUDY GARLAND—SECONAL SODIUM: 97 mg." And behind it, reflected in the shards of glass, a motionless figure slumped over by the commode. There was a knock at the door, and a man's voice, raspy and deep from the lungs, bellowed from the other side. "It's locked, are you in there?"

In the bedroom, Mickey stood outside the door. "Hello? Open up!" Silence. He knocked again. "Are you in there?! Come out!" A third time,

knocking harder. "OPEN THE DAMN DOOR!" He screamed, hammering, banging, pounding, rattling the door frame.

The sight was a loop from the beginning, appearing full-circle. A grotesque image of blue skin and rigor mortis, broken glass and pills scattered about, but nonetheless the reality of tragedy. Judy Garland, birth name Frances Ethel Gumm, dead on the bathroom floor.

The funeral in New York City might as well have reflected the death of a queen. Endless series of cars, flowers, photographers, news cameras, overflowing crowds of an estimated twenty-thousand people lining up to pay their respects at Frank. E. Campbell Funeral Chapel. Her body was flown to Hollywood Forever Cemetery. Burning candles dripping with wax, autographed pictures, cards, ruby slippers, memorabilia, roses placed everywhere. Engraved tombstone: "JUDY GARLAND: 1922—1969"

Every day, people walk over the coral-pink five-pointed brass stars on the terrazzo sidewalk, crossing Hollywood Boulevard and Vine Street. Sweeping over the pavement, moving past feet stomping over the names of honorees—Clark Gable—Marilyn Monroe—Frank Sinatra—Lucille Ball—each with emblems for their contributions in film, television, music, radio and theater. The Judy Garland star rested among them.

And, of course, every year at Thanksgiving, families' feast on turkey and yams, conversing at the table. Lo and behold, *The Wizard of Oz* often

plays on TV in the background, remastered in high-definition for its yearly broadcast. The heels of sparkling ruby slippers appeared onscreen, tapping together on yellow bricks ...click ...click ...click...a glimmer from the jewels, flooding the pixels with magical glittering light...

<u>THE END</u>

About the Author

At only twenty-eight, Michael Lee Simpson is a multi award-winning writer with some of the top accolades in the industry. He writes both fiction and non-fiction, with subjects ranging from fantasy, drama, horror and biographical. His first screenplay, "Worthy of Gold," portrays his great-uncle who won a gold medal for wrestling in the 1932 Olympics—winning Best Screenplay in the Austin Film Festival and WorldFest Houston. His second, "Warwolf," depicts the haunting reality of a soldier cursed to prowl by night as a werewolf on the battlegrounds of World War I. Third, "Lost on the Yellow Brick, and fourth and fifth, with unknown plots, "The Devil's Graveyard" and "A World of Clocks & Mirrors." Most notably, Simpson became a semi-finalist in the Academy Nicholl Fellowships in Screenwriting two years consecutively. He also served as a film critic for The Kansas City Star and Technical Director for "We The People," an IMAX film. He was born and raised in Kansas City, Kansas, and graduated from the University of Kansas. With many projects on the timetable, and running his own graphic design business, he continues to engage in the creative process. He now lives in Ocala, Florida.

CPSIA information can be obtained
at www.ICGtesting.com
Printed in the USA
LVHW021036110820
662879LV00017B/546